A CONFLATION OF ART AND SCIENCE

A CONFLATION OF ART AND SCIENCE

WEIRD SCIENCE

MARK DION

GREGORY GREEN | MARGARET HONDA

ANDREA ZITTEL

CRANBROOK ART MUSEUM

WITH CONTRIBUTIONS BY GREGORY WITTKOPP
IRENE HOFMANN
MICHELLE GRABNER
DAVID WILSON

CRANBROOK ART MUSEUM

JANUARY 30 THROUGH APRIL 3, 1999

WEIRD SCIENCE: A CONFLATION OF ART AND SCIENCE
was published in conjunction with the exhibition of
the same title, presented by Cranbrook Art Museum
and curated by Irene Hofmann.

EDITOR Dora Apel
PHOTOGRAPHER Kirt King

Cover detail, Mark Dion, *Selections from the
Herpetology Collection of Cranbrook Institute
of Science,* 1999. Photo by Kirt King.

ART MUSEUM

ISBN # 0-9668577-0-4

Cranbrook Art Museum is a non-profit contemporary
art museum. The Art Museum is part of Cranbrook
Educational Community, which also includes Cranbrook's
Academy of Art, Institute of Science, Schools and other
affiliated cultural and educational programs.

CONTENTS

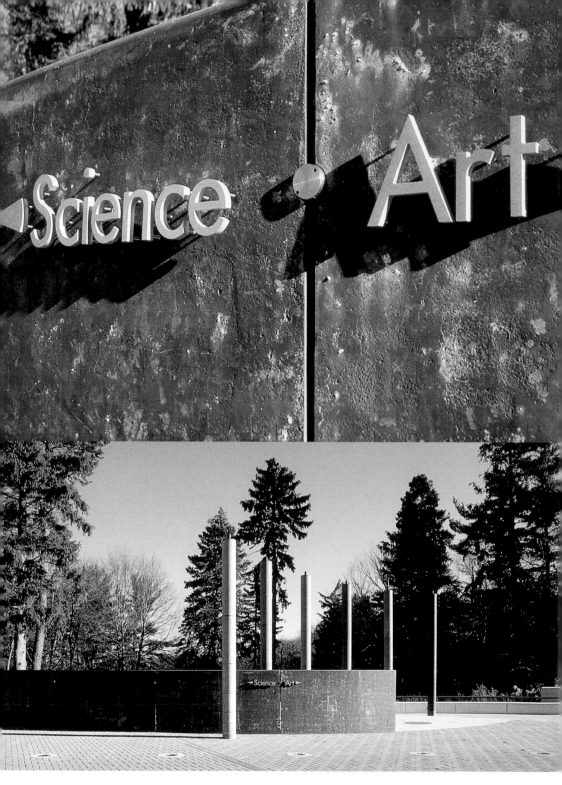

FIGS. 1 AND 2 (ABOVE AND BELOW). JUHANI PALLASMAA (ARCHITECT), *ARRIVAL FEATURE,* CRANBROOK EDUCATIONAL COMMUNITY, COMPLETED 1994. THE *ARRIVAL FEATURE,* INCORPORATING A CONVEX BRONZE WALL DENOTING SCIENCE AND A CONCAVE SIX-COLUMNED GRANITE COLONNADE DENOTING ART, IS LOCATED MIDWAY BETWEEN CRANBROOK'S INSTITUTE OF SCIENCE AND ACADEMY OF ART AND ART MUSEUM. THE LETTERING AND ARROWS POINTING IN THE DIRECTIONS OF SCIENCE AND ART WERE ADDED IN 1998. PHOTOS BY BALTHAZAR KORAB, COURTESY OF CRANBROOK ARCHIVES.

ART AND SCIENCE

AT CRANBROOK

ART AND SCIENCE HAVE ALWAYS EXISTED AT CRANBROOK IN CLOSE PROXIMITY TO ONE ANOTHER.
By establishing both an Institute of Science and an Academy of Art and Art Museum on the same campus in the 1920s and 1930s, George Booth, Cranbrook's founder, certainly saw the potential for the forms of knowledge and experience produced by art and science to enrich each other and at times he even encouraged a certain fluidity between elements of the two disciplines. The Institute of Science, in fact, evolved from a collection of rare minerals that Booth initially bought because he thought their natural colors and crystal forms could serve as "an aid to art education."[1] It was only after Booth had installed the minerals in his house, where "he made many arrangements, wholly from an artistic standpoint,"[2] that he moved this collection to the halls of the Institute where they were catalogued as geological specimens and began their second role at Cranbrook as an aid to science education (FIG. 3). More often than not, however, the potential for cross-fertilization between art and science lay dormant as the two museums formalized their collections and programs and set their own separate agendas.

The impetus for *Weird Science* was the recent expansion of the Institute of Science. In 1998 the Institute completed a 33,000 square-foot addition, doubling the size of the museum that Eliel Saarinen designed in the late-1930s. Realizing that the new building, designed by Steven Holl, coupled with a complete reinstallation of the Institute's collections and exhibits would generate great interest and attract new audiences to our shared campus, I challenged Associate Curator Irene Hofmann to develop an exhibition for the Art Museum that would arouse the collaborative potential of art and science at Cranbrook.

Scientific developments at the end of the millennium have been as breathtaking as the cloning of Dolly the sheep in Scotland, and the previously unimaginable images of the Universe and the afterglow of the Big Bang provided by the Hubble Space Telescope and other satellites. While artists have responded in a variety of ways to these developments, Hofmann sought works that deliberately adopt the rhetoric and practices of science. She selected the work of four artists who interrogate the influence and authority of the field of science even as they employ its methods and respond to its seductions. Three of the artists—Mark Dion, Gregory Green and Margaret Honda—created new work for this project, giving

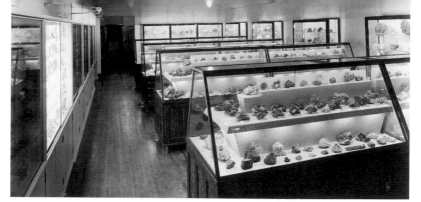

FIG. 3. MINERAL HALL, CRANBROOK INSTITUTE OF SCIENCE, APRIL 1936. PHOTO COURTESY OF CRANBROOK ARCHIVES.

them an opportunity to either advance ideas they have been exploring for several years (Green's *Proto III* satellite and Honda's *Hibernarium*) or, in the case of Dion, to create two new site-specific installations which literally flip the context for science at Cranbrook by moving selections from the Institute's vast holdings, including most of their herpetology collection, to a dramatic new presentation at the Art Museum. For the fourth artist, Andrea Zittel, *Weird Science* is an opportunity to place her earlier chicken breeding project in the context of science, a context that was perhaps less apparent in its presentations in 1993 at The New Museum in New York and the Venice Biennale or at its permanent home in Los Angeles at The Museum of Contemporary Art.

At the same time we asked artist and museum director David Wilson to contribute to this project with an essay for the catalogue. Wilson's essay explores one of the earliest displays of "weird science," Athanasius Kircher's seventeenth-century Musaeum Kircherianum in Rome. Like Wilson's own present-day museum near Los Angeles, The Museum of Jurassic Technology, Kircher's museum told a variety of strange and fantastic stories, finding space between the realms of fact and fiction to create wonder.

David Wilson, like Kircher and Mark Dion, drew some of his inspiration from the *Wunderkammern*, or "cabinets of wonders" that developed in Europe in the early part of the sixteenth century. With their random juxtapositions of scientific objects, natural curiosities, and art objects (Peter the Great's cabinet in Russia, for example, included his favorite surgical instruments and a two-headed sheep as well as portraits, statues, and reliefs),[3] these *Wunderkammern* contained the marvels of a rapidly expanding world. Of course George Booth, knowingly or not, was also indebted to these early museums, whose purpose resided as much in the wonder they aroused as in the enlightenment they provided. I think George Booth would have enjoyed *Weird Science*, whether or not he recognized the critique.

GREGORY WITTKOPP
Director, Cranbrook Art Museum

1 Lee A. White, "Before the Beginning," *Cranbrook Institute of Science: A History of Its Founding and First Twenty-Five Years* (Bloomfield Hills, Michigan: Cranbrook Institute of Science, 1959), 11-12.

2 Chester B. Slawson, "The Mineral Collection," *Cranbrook Institute of Science*, 129.

3 Rosamond Wolff Purcell and Stephen Jay Gould, *Finders, Keepers: Treasures and Oddities of Natural History, Collectors from Peter the Great to Louis Agassiz* (New York: W. W. Norton & Company, 1992), 18.

ACKNOWLEDGMENTS

WEIRD SCIENCE would not have been possible without the assistance and hard work of many friends and colleagues. To all who helped realize this exhibition and catalogue, I am enormously indebted. Foremost, I would like to thank Gregory Wittkopp, Director of the Art Museum, who has offered his enthusiasm, guidance and support throughout this project. I am incredibly grateful for all he has contributed. Also at Cranbrook Art Museum I would like to thank Jess Kreglow, Preparator, who contributed great skill and devotion to the exhibition installation. My thanks also go to Barbara Moon Boertzel, Manager of The Store; Denise Collier, Administrative Assistant; Ashley Brown, Collections Intern; and Marlayna Schoen, Museum Secretary/Tour Coordinator, who each offered much assistance throughout this project.

To Dora Apel who served as Editor, I am grateful for her insights and thank her for her council and support and for bringing clarity to my essay. For their inspired work on the catalogue, I offer my gratitude and admiration to art director Laurie Haycock Makela and designer Brigid Cabry of Words + Pictures for Business + Culture. Their design has captured the dynamic character of the artists in this exhibition. Thanks also go to Kirt King for his photography for the cover of the catalogue. I am also very grateful to Michelle Grabner who conducted thoughtful interviews with each of the participating artists, and to David Wilson who contributed an intriguing essay to the catalogue. Thanks are also due to the Cranbrook Archives staff—Mark Coir, Marsha Miro, Catherine Price and Ryan Weiber—for their assistance in locating materials for the catalogue.

I would also like to thank all who offered their kind assistance securing loans, supplying photographs and countless other details: John Connelly and Andrea Rosen at Andrea Rosen Gallery, New York; Liz Pryor at The Museum of Contemporary Art, Los Angeles; Shoshona Blank at Shoshona Wayne Gallery, Santa Monica; Daniel McDonald and American Fine Arts, Co.; The Public Art Fund, New York; and Feigen Contemporary, New York.

Gregory Wittkopp and I would both like to thank our many colleagues at Cranbrook's Institute of Science for the significant roles they have played in this project. To Elaine Gurian, Acting Director; Lucy Bukowski, Deputy Director; Michael Stafford, Curator of Collections; Carole DeFord, Collections Manager; Mark Uhen, Curator of Paleontology; Larry Hutchinson, Curator of Exhibits; Michelle Goyette, Coordinator of Nature Programs; Melissa Pletcher, Special Events Coordinator; and Maureen Leonard and Laura Arnsbarger, Public Relations Specialists, we offer our gratitude and respect for the remarkable work they do and thank them for their enthusiasm and contributions to this project.

Finally, I would like to thank the four artists in the exhibition, Mark Dion, Gregory Green, Margaret Honda and Andrea Zittel. It has been a great pleasure working with each of them on this exhibition. I am grateful for their dedication to this project and for the remarkable works they contributed.

IRENE HOFMANN
Associate Curator, Cranbrook Art Museum

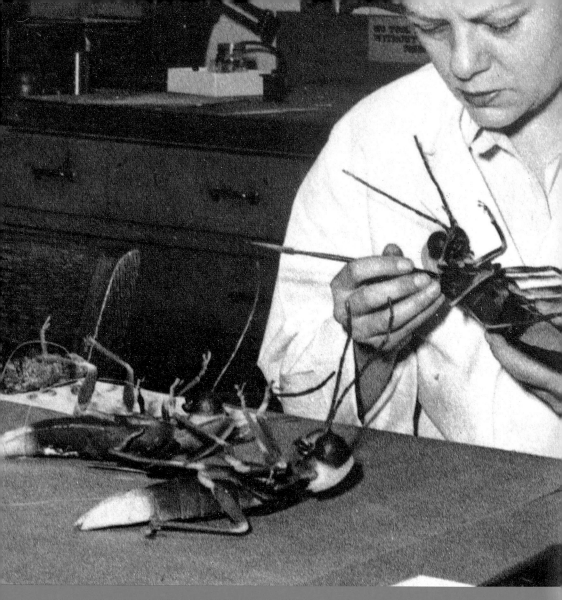

FIG. 4. LUELLA C. SCHROEDER, SCIENTIST, CRANBROOK INSTITUTE OF SCIENCE, 1951. PHOTO COURTESY OF CRANBROOK ARCHIVES.

WEIRD SCIENCE

A CONFLATION OF ART AND SCIENCE

by Irene Hofmann

ALTHOUGH ADVANCEMENTS IN SCIENCE AND TECHNOLOGY HAVE SHAPED THE COURSE OF HUMAN LIFE THROUGHOUT HISTORY,
the twentieth century has witnessed perhaps the most astounding scientific developments the world has ever known. With current science and technology, we possess the ability to rapidly and decisively alter our existence and manipulate the natural world in ways never before imaginable. From the development of nuclear and biological weapons to the ability to clone animals, twentieth-century science has led us into new and often terrifying areas, forcing us to question the political implications and ethical consequences of each new discovery and advance.

Weird Science brings together four artists' projects, each one representing an ongoing exploration of a specific area of scientific inquiry into these issues of morality and practice. More than just referencing science visually, these works were conceived and created using the same language, strategies and protocols as the field of science. While each of these projects focuses on a different area of scientific exploration (natural science, nuclear physics and rocket science, zoology, and genetic engineering), inherent in each project is a critique or questioning of the influence, authority, and effects of the scientific field. By deliberately adopting the practices of science, Mark Dion, Gregory Green, Margaret Honda, and Andrea Zittel reveal the potential dangers and shortcomings of a field in pursuit of definitive conclusions, categorizations, truth, and progress.

While each artist presented in *Weird Science* borrows from the practices of science in the creation of their work, what differentiates them from their scientist counterparts is that they each do so firmly positioned within the rubric of art. For it is the language and construct of art, not science, that provides these artists with the license to execute the varied critiques and explorations revealed in these four projects. As Mark Dion explains, scientists "don't have access to the rich set of tools, like irony, allegory and humor, which are the meat and potatoes of art and literature."[1] Equipped with the authority and legitimacy of science, along with these powerful "tools" of art, each artist in this exhibition has created a project aimed at exposing the liabilities of science, scrutinizing its structures, and challenging the presumed objectivity of its practices.

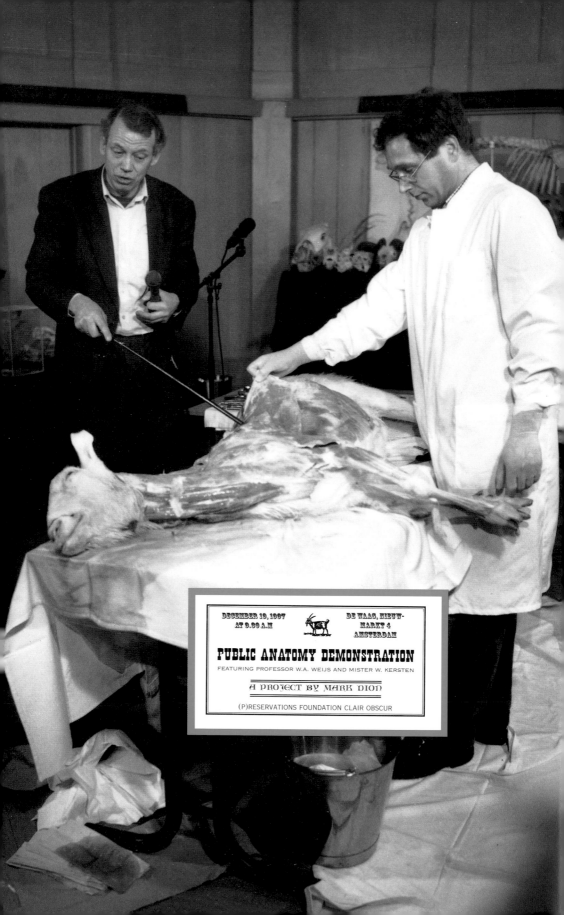

DECEMBER 19, 1997
AT 9.00 A.M

DE WAAG, NIEUW-
MARKT 4
AMSTERDAM

PUBLIC ANATOMY DEMONSTRATION

FEATURING PROFESSOR W.A. WEIJS AND MISTER W. KERSTEN

A PROJECT BY MARK DION

(P)RESERVATIONS FOUNDATION CLAIR OBSCUR

MARK DION

An avid bird watcher, explorer, environmental activist, and amateur naturalist, Mark Dion immerses himself in nature and the collections of science and natural history museums as part of an ongoing investigation of our culture's representations of the natural world. With large-scale installations, laboratory constructions, fieldwork research, and provocative writings, Dion explores our culture's ideas about nature and the environment while challenging the practices of the natural sciences and natural history museum. Variously assuming the role of zoologist, ecologist, archeologist and museum curator, Dion scrutinizes the processes of these disciplines, revealing their traditionally rigid language and structures and deconstructing our culture's prevailing representations of nature. Initially addressing issues of ecology, environmental disruption, biodiversity and species extinction in his early work, in Dion's recent projects he has directed his inquiries toward the conventions of natural history museums and how their activities—both in the field and in the museum—form and perpetuate our current understanding of the natural world. For many of these projects Dion becomes involved in the very activities he seeks to question, offering up the processes of natural science for scrutiny.

In 1991, for example, Dion developed a series of fictional bureaucracies and laboratories engaged in the collecting, classification, and taxonomy of plants and animals, with the purpose of questioning the arbitrary nature of these practices. For *The Department of Marine Animal Identification of the City of New York (Chinatown Division)*, 1992, one of three invented bureaucracies in this series, Dion began by gathering as many specimens of marine life as he could find in New York's Chinatown fish markets (FIG. 22). Once these were all collected, Dion brought the fish back to the gallery space at American Fine Arts, Co., where the project was executed. With textbooks and identification manuals, Dion identified, labeled, and preserved each specimen in a glass jar filled with alcohol. Over the course of Dion's work, the public was invited to view the artist and monitor his progress. When the project was complete, a metal cabinet filled with identified marine specimens remained in the gallery. The following year in Munich, Dion created a similar project

called *The Great Munich Bug Hunt*, 1993 (FIG. 7). In this work, an enormous dead tree collected from the Black Forest was installed in a gallery space allowing Dion, along with a group of local entomologists, to drill into the tree in search of the invertebrae living inside. As specimens were extracted and identified, they were placed in glass jars and housed in a wooden cabinet. Once again, Dion and his team were on view in the gallery during this project, allowing visitors an opportunity to see their progress and engage them in dialogue about their work.

Works such as *The Department of Marine Animal Identification* and *The Great Munich Bug Hunt* are aimed at challenging the structures of natural history's practices of classification and representation; at the same time, however, they present the highly seductive nature of these very activities and methods. The specimen-filled cabinets that resulted from these performative works, for example, reveal the allure of order and taxonomy. Dion admits that the pleasure he takes in the processes of creating these works comes "dangerously close to absorbing him into the rubric he wishes to expose."[2] This contradiction in Dion's work also points to one of the great contradictions of the naturalist. The subject of Dion's critique, the naturalist, at times INSATIABLE, OBSESSIVE, AND COLONIALIST, is also the very figure whose activities, however biased, serve to preserve and make visible the secrets of nature.

While projects such as *The Department of Marine Animal Identification* and *The Great Munich Bug Hunt* involve the creation of mock "collections" through the organization and classification of specimens, there is another aspect of Dion's current artistic practice that involves working directly with the existing collections of a science or natural history museum. These projects critically examine the history of nature as it is represented and perpetuated by natural history museums. By engaging the natural history museum through the use of its collections, Dion is able to address the very institution that now defines much of our knowledge of the natural world. As Dion explains, "These museums are one of the most essential sites for any investigation into how a dominant cultural group constructs and demonstrates its truth about nature. It is here we find 'the official story'."[3] Gaining access to the collections of the world's most important natural history museums, Dion is able to critique this "official story" of nature, revealing the limits of the knowledge they propagate, the bias of their collections, and the rigidity of their organization. These projects hold a mirror up to the institutions Dion works with, calling into question the scientific methodologies that have been traditionally employed. In *Collectors Collected*, 1997, for example, Dion was invited to create a project at the Rome Museum of Zoology utilizing the collections he found there. In this installation Dion sought to expose the biases of the natural history museums by displaying details about the naturalists, zoologists and explorers who had produced the museum's collections. Within many glass vitrines, Dion arranged specimen tags, instruments, and storage boxes revealing the process of the scientific method (PLATE III). In other vitrines, Dion formed portraits of individual naturalists

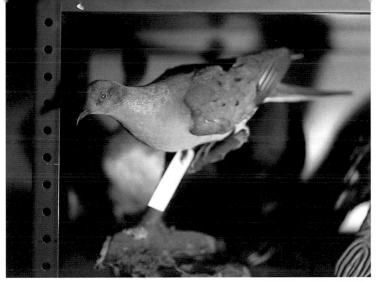

FIG. 6. PASSENGER PIGEON FROM THE COLLECTION OF CRANBROOK INSTITUTE OF SCIENCE. PHOTO BY KIRT KING.

or explorers by displaying their clothing, microscopes, charts, cages, traps, rifles, and camping equipment (PLATE I). Dion explained that he wished to portray the lives of these men in much the same way they would have exhibited the people and cultures they might have "discovered" during their collecting expeditions.[4]

Evoking an earlier era in the study of natural history—a time of passionate collecting when nature's marvels were celebrated—Dion's new project for *Weird Science* takes the form of a two-part installation, with each component featuring some of the curiosities of the collection of Cranbrook's Institute of Science. In these two works, Dion recalls a time when collections of nature were part of the realm of the extraordinary, a distinction now lost in the modern natural history museum's rigorous process of collecting and housing specimens. As historians Lorraine Daston and Katharine Park note, "Since the Enlightenment, wonder has become a disreputable passion in workaday science, redolent of the popular, the amateurish, and the childish. Scientists now reserve expressions of wonder for their personal memoirs, not their professional publications. They may acknowledge wonder as a motivation, but, they no longer consider it part of doing science."[5]

In *Buried Treasure (from the Collection of Cranbrook Institute of Science) I* and *II*, Dion draws on the tradition of the *Wunderkammer* to create two cabinets filled with some of the remarkable and rather bizarre inclusions in the Institute's collections of natural history. The *Wunderkammer*, or curiosity cabinet, appeared throughout Europe during the sixteenth and seventeenth centuries, housing idiosyncratic collections of rare ethnographic objects, oddities of nature, and other fantastic discoveries in cabinets or cupboards. These collections—often showcases of the travels and acquisitions of the aristocracy—are predecessors to the modern museum and represent a time before classifying and ordering practices had been established.[6] For Dion, the *Wunderkammer* embodies a pre-Enlightenment tradition of presenting nature, before man was compelled to rationalize, control, and organize the natural world. Art historian Barbara Stafford observes, "Current focus on

the rational order shaping Enlightenment 'museum culture' has served to obscure, however, the existence of meaningful *Wunderkammer* arrangements prior to the advent of scientifically sequenced works." Stafford comments, "The shift [during the Enlightenment] from sensory impact to a rationalizing nomenclature was also a move from the extraordinary to the ordinary."[7] It is these meaningful and extraordinary "arrangements" of the *Wunderkammer* that Dion now recalls and recreates in his curiosity cabinets.

For Cranbrook Art Museum's *Wunderkammern*, Dion has filled two Eliel Saarinen-designed display cabinets with some remarkable objects from the storage rooms of the nearby Institute of Science. A Passenger Pigeon, a bird extinct since 1914, is one of the featured wonders in the cabinets (FIG. 6).[8] A large egg from Madagascar's prehistoric flightless *Aepyornis* (elephant bird), which had at one point been shattered and later reconstructed, is another highlight in these collections of seemingly incongruous objects and specimens (PLATE VII). Like its predecessors, Dion's *Wunderkammern* offer an open narrative, an opportunity to present objects in arbitrary arrangements that are free of the rational, pedagogical structures that dictate the display of such objects in a modern natural history museum. Not only does Dion adopt the form of the *Wunderkammer* to evoke a time when collections were idiosyncratic, fetishistic, and fantastic, but, as the artist explains, this format offers a rare opportunity to reveal what is often hidden from public view: "I must confess a fondness for curiosity cabinets, particularly since they most closely resemble THE SURREALISTIC QUALITY OF THE BACK ROOM OF MANY MUSEUMS, rather than the exhibition galleries."[9] Bringing the Institute of Science's curiosities out of storage and into a new and liberating context, we are offered an opportunity to re/discover these marvels for ourselves.

A second work in Dion's *Weird Science* installation, *Selections from the Herpetology Collection of Cranbrook Institute of Science*, involves a dramatic recontextualizing of the Institute of Science's collection of amphibians and reptiles. For this work, Dion selected nearly three hundred specimens from the museum's collection of snakes, frogs, turtles and lizards that are set in formaldehyde and stored in glass jars of alcohol. Each specimen is installed on top of a twenty-five-foot long table that spans the width of the gallery. The only light in an otherwise darkened gallery space comes from within the massive table. With fluorescent light traveling through every jar of liquid, each specimen takes on a magical quality — every minor scale, horn, and bump on these animals becomes extraordinary (PLATE II). By simply lighting these specimens in this way, Dion asserts the enigmatic qualities of nature and re-mystifies a collection of objects that have lost their potency in the didactic world of the natural history museum. Through his Cranbrook Art Museum installation Dion seeks to reestablish a sense of mystery and wonder in natural history's great collections.

COLLECTORS COLLECTED, MUSEO CIVICO DI ZOOLOGIA, ROME

1997, VITRINES, VARIOUS OBJECTS.

PHOTO BY A. INDINI, COURTESY OF AMERICAN FINE ARTS CO., NEW YORK.

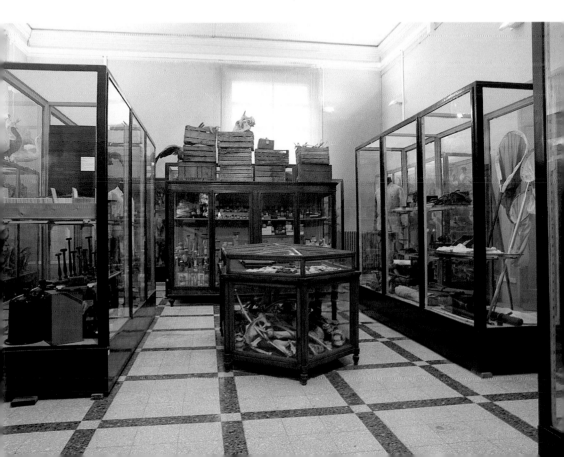

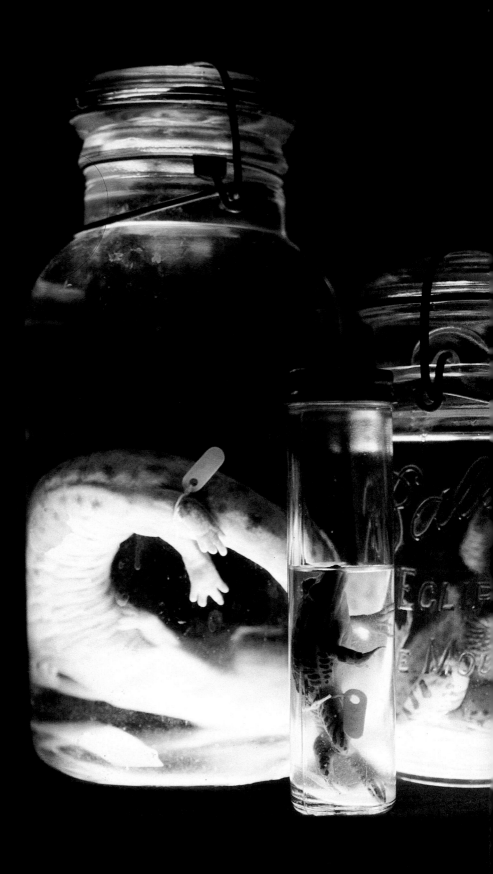

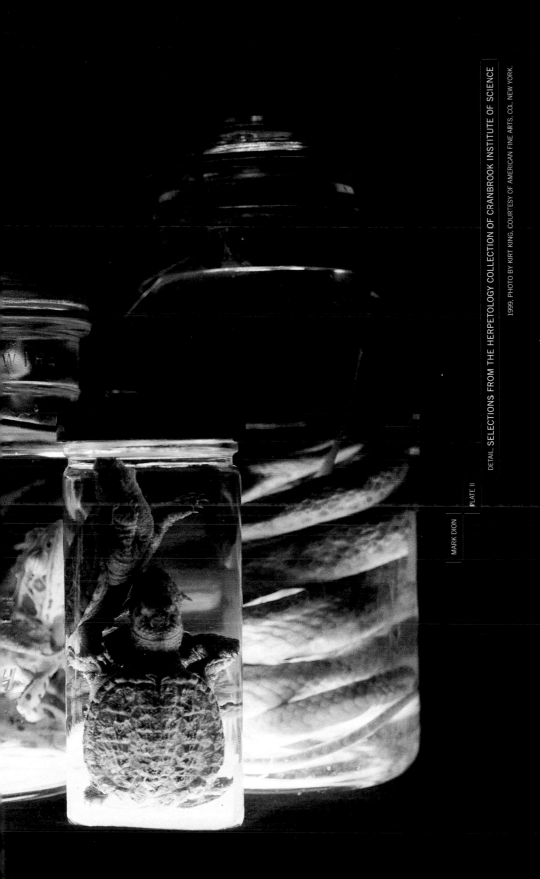

MARK DION | PLATE II

DETAIL, SELECTIONS FROM THE HERPETOLOGY COLLECTION OF CRANBROOK INSTITUTE OF SCIENCE

1999, PHOTO BY KIRT KING, COURTESY OF AMERICAN FINE ARTS, CO., NEW YORK.

MARK DION

PLATE III (L)

DETAIL, COLLECTORS COLLECTED, MUSEO CIVICO DI ZOOLOGIA, ROME

1997, VITRINES, VARIOUS OBJECTS.
PHOTO BY A. INDINI, COURTESY OF AMERICAN FINE ARTS CO., NEW YORK.

FIG. 7 (R)

THE GREAT MUNICH BUG HUNT

1993, TREE COLLECTING CABINET, SPECIMENS, LAB EQUIPMENT.
PHOTO COURTESY OF AMERICAN FINE AFTS CO., NEW YORK.

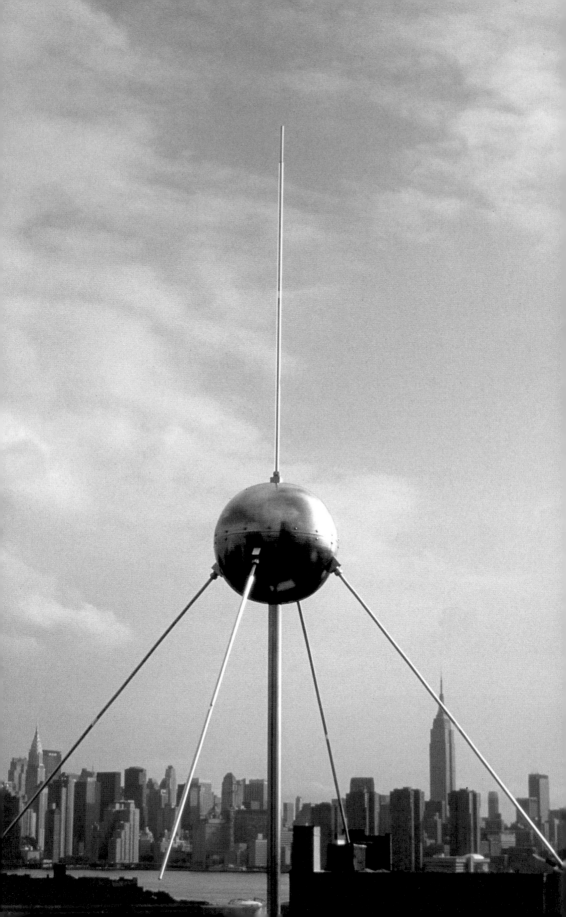

GREGORY GREEN

Armed with a collection of chilling mail-order "how to" manuals and a desire to question systems of violence and the technology of destruction, Gregory Green's work over the last decade has focused on developing a series of seven large-scale projects that investigate various strategies of individual and collective empowerment. Beginning with a phase that Green calls the Terror Group, consisting of works that reference terrorism and devices of mass destruction, and concluding with the passive and yet-to-be executed Non-Participation Group, Green seeks to examine the range of tactics of empowerment from violent to non-violent means. With each phase realized to date, Green has explored various systems of societal control, revealing the power of technology and the ease with which an individual can access information about its more menacing and destructive possibilities.

Perhaps the most unnerving works from Green's series of projects are those linked to the Terror Group. This group of works features various implements of violence including pipe bombs, atomic devices, missiles, and recipes for explosives. Using information and instructions gathered from the library, the Internet, and small presses available through mail order, Green was able to build a remarkable arsenal of potentially lethal weapons. In works such as *Suitcase Bomb #6 (New York)*, 1996, for example, a small suitcase carries two fully-wired pipe bombs (FIG. 10). All that is missing is the black powder necessary to create an explosion. As Green explains, "Where one would normally find black powder or any other explosive agent, a recipe for mixing black powder from commercially available materials is provided. The responsibility for actually completing a live weapon is left in the hands of the owner [of the piece]." [10]

Companions to objects like these are a series of *Work Table* installations. In these works Green sets up makeshift laboratories for the creation of terrorist devices. Tables are filled with instruction manuals, batteries, egg timers, wires, lead pipes, and various other everyday materials which can be turned into a bomb. With works like *Work Table #5*, Green makes evident that these terrifying devices are relatively low-tech and can be made from

common household items (PLATE V). Green observes, "If you can cook from a cookbook, you can build just about anything."[11] While Green's works in the Terror Group have taken many forms, they each call our attention to the ease with which one can access lethal information, encouraging a dialogue about alternative means of individual and group empowerment.

Although the science behind the development of a nuclear device is far more involved than building a pipe bomb, Green demonstrates with his Nuclear Bomb series that information about this once heavily guarded technology is not only easily available, but not too complicated to duplicate. In *Nuclear Device #3*, 1995, for example, Green creates a mechanically complete and potentially functional nuclear bomb (FIG. 11) following the directions he found in an instruction book called *The Joy of Killing: 500 Different Ways to Kill*, a publication available by mail order. All that is missing from this and other nuclear devices built by Green is the plutonium necessary TO DELIVER THE BLAST. Although plutonium is certainly a difficult material to come by, as Green points out, "It is estimated that at least two tons of plutonium are unaccounted for in the United States."[12]

Accompanying Green's various nuclear devices are a series of rockets capable of delivering a nuclear payload to a desired destination. *RCSASM #4 (Mega-Magnum)*, 1995, is a two-stage radio controlled surface-to-air missile with a range of twenty miles and an approximate potential speed between four hundred and five hundred miles per hour (FIG. 12). Once again, one critical element—a fuel canister—is missing from this otherwise mechanically complete missile. These nuclear bombs and large-scale guided rockets led Green to a related project—a space program of sorts called *Gregnik*. Green's largest and most ambitious project to date, *Gregnik* reveals the artist's passion for space (growing up on a military air base in Satellite Beach, Florida, Green often watched the Apollo mission launches and dreamed of being an astronaut) and represents an exploration of a non-violent strategy of empowerment. For *Weird Science*, Green brings together the first two research and development phases of *Gregnik* as well as a newly completed third phase.

Gregnik was first conceived in the summer of 1995 as an alternative space program that would restage the former USSR's *Sputnik* program on an independent level. With *Gregnik*, Green recalls an anxious moment in U.S. history when, on October 4, 1957, the Soviet Union launched *Sputnik*, the first artificial earth satellite. Although *Sputnik* only weighed about 185 pounds and had a diameter no bigger than a basketball, it was an unanticipated technological achievement that signaled Russia's nuclear superiority and radically redefined the balance of power between the world's two super powers.[13] Ostensibly an innocuous satellite that emitted a short-wave radio signal consisting of a series of steady beeps, *Sputnik* was nonetheless a startling display of Russia's advancements in science and technology, and, in effect, signaled an escalation of the arms race and a terrifying new phase of the Cold War. Modeled after the original *Sputnik*, Green's *Gregnik* project is centered around the actual launch of a satellite into a low-level orbit over

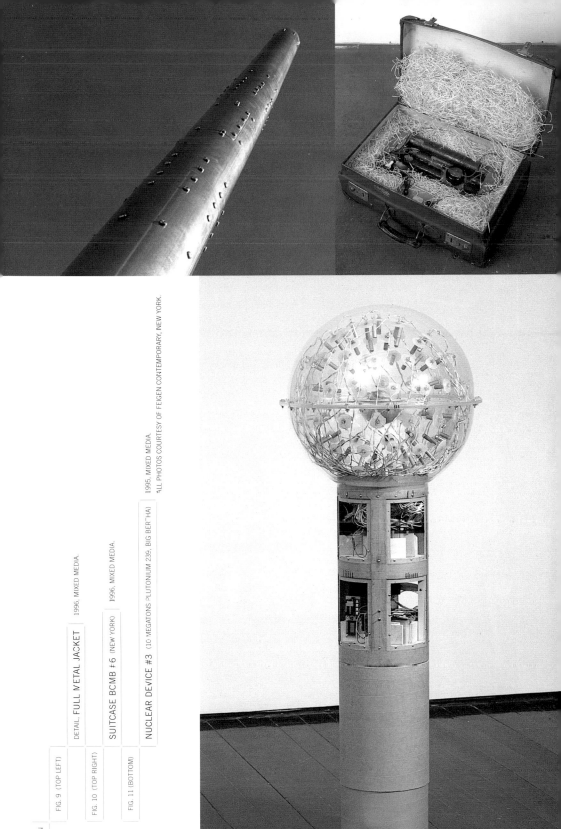

GREGORY GREEN

FIG. 9 (TOP LEFT) DETAIL, FULL METAL JACKET 1996, MIXED MEDIA.

FIG. 10 (TOP RIGHT) SUITCASE BOMB #6 (NEW YORK) 1996, MIXED MEDIA.

FIG. 11 (BOTTOM) NUCLEAR DEVICE #3 (10 MEGATONS PLUTONIUM 239, BIG BERTHA) 1995, MIXED MEDIA.

ALL PHOTOS COURTESY OF FEIGEN CONTEMPORARY, NEW YORK.

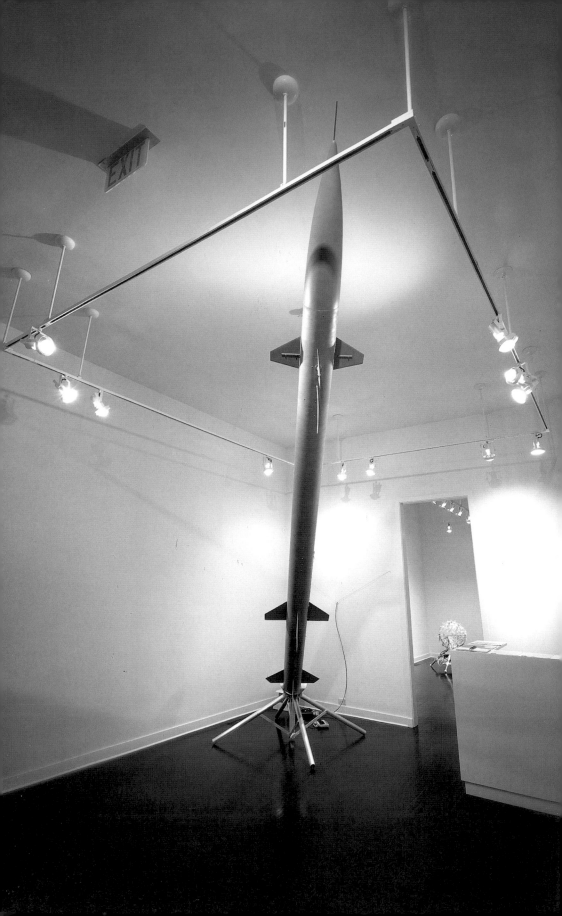

the Earth's Northern Hemisphere. Green estimates that *Gregnik's* orbit will last about two months, during which time it will broadcast to Earth on an FM frequency. Although the launch of *Gregnik* is not intended to incite the kind of global fear and paranoia that *Sputnik* created in 1957, it makes reference to many of the unsettling issues surrounding *Sputnik*. As Green explains, he is interested in "producing a similar reexamination of the roles and relationships of the state, the individual, and technology in our contemporary global society."[14]

The first phase of *Gregnik* was the creation of *Proto I* or *Gregnik (First State)*, 1996 (PLATE IV). Sponsored by Locus+ in Newcastle, England, the design of this prototype focused on the development of the satellite's casing as well as its broadcast and power systems. When this prototype was completed, it was briefly installed on a rooftop in downtown Newcastle where it broadcast a 120-minute tape loop that Green created in collaboration with some of the residents of Newcastle. The repeating broadcast consisted of monologues and interviews with the residents of Meadowell Estates, a Newcastle housing project infamous for a series of destructive riots that broke out in the neighborhood in 1989 over a Poll Tax. Green's broadcast from *Proto I* during the summer of 1996 provided a powerful alternative forum for the many voices of the residents of Meadowell.

Proto II, Gregnik's second research and development phase, was sponsored by the Public Art Fund in New York and installed on the roof of a warehouse in the Williamsburg neighborhood of Brooklyn (FIG. 8). This second *Gregnik* prototype was more advanced than *Proto I*, functioning as a low-level FM radio transmitter that was wired to broadcast live to a local audience. Over the course of the installation, Green offered over fifty local artists access to the airways and an opportunity to broadcast their sound work. The beginning of this four-week installation and FM radio transmission opened on October 4, 1997, the fortieth anniversary of the launch of *Sputnik*.

For *Weird Science*, Green premieres *Proto III*, coming one step closer to the launch of a fully operational satellite. With a newly designed exterior casing and an advanced system of antenna, this third design represents the last phase of prototyping for the final satellite. During the installation of *Proto III* at Cranbrook Art Museum, this satellite, like its predecessors, will transmit an FM broadcast to the immediate surrounding community. The broadcast will consist of a compilation of recordings by adolescents and senior citizens from the metropolitan Detroit area, with each participant telling of their hopes and dreams for the future. These recordings from the community, and others like them, will become the basis for *Gregnik's* eventual broadcast from space. With the completion of *Proto III*, Green will begin the complicated process of securing support for the actual launch of *Gregnik* so that it may find its way into space in time for the new millennium.

ESSAY CONTINUES ON PAGE 39 / *HOFMANN* 27

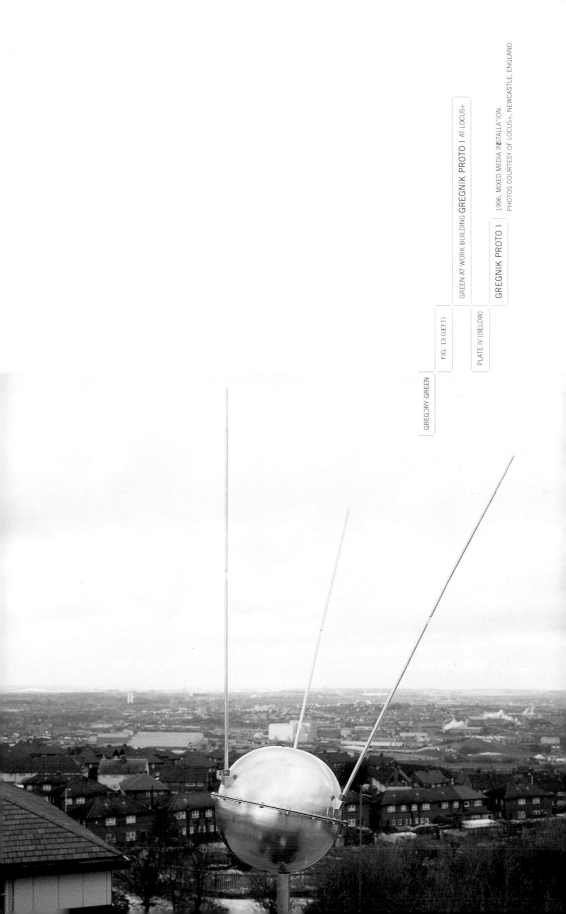

GREGORY GREEN

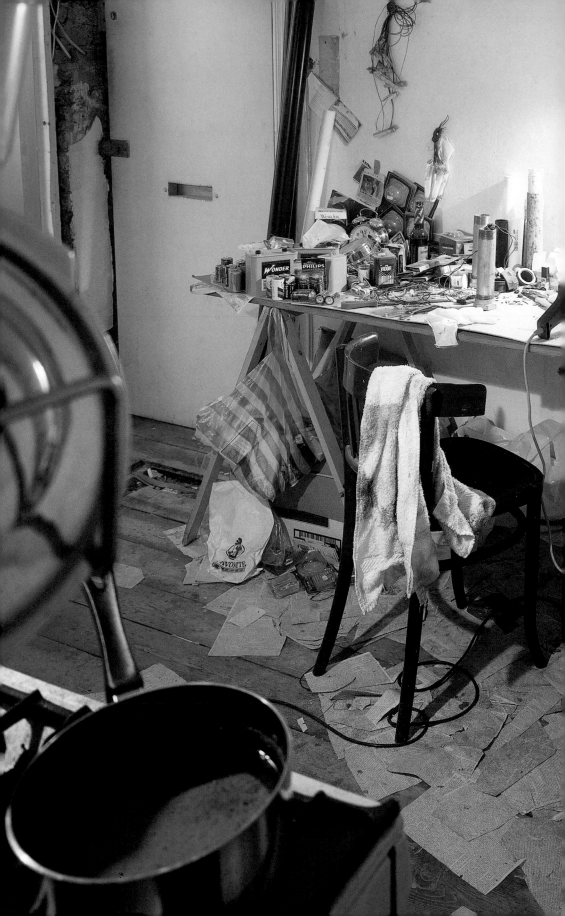

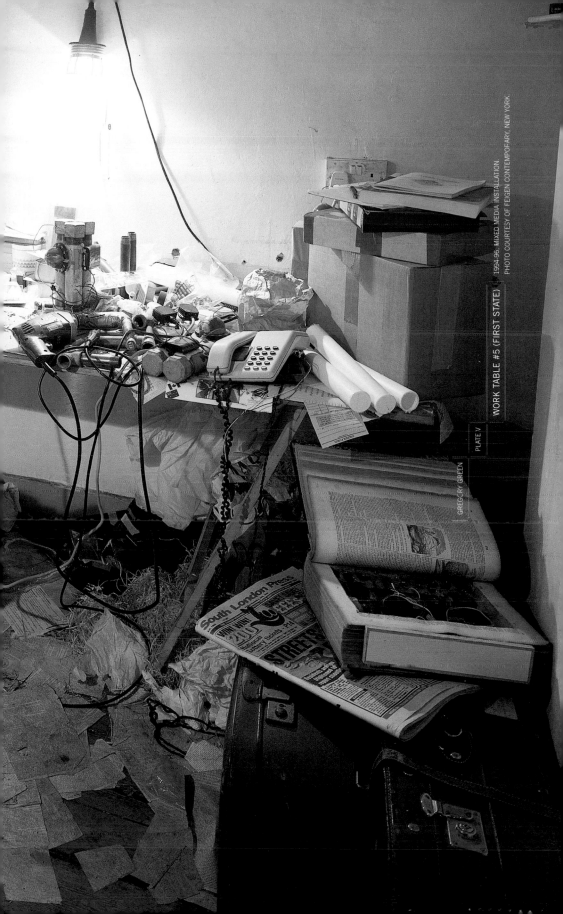

MARGARET HONDA

PLATE VI (L)

DETAIL, **HIBERNARIUM**

1998. *TERRAPENE CAROLINA CAROLINA*. ALUMINUM, SINTRA, ORCHID BARK, PAPER, MOSS, WATER, ROCKS, BORESCOPE. PHOTO BY GENE OGAMI. COURTESY OF THE ARTIST AND SHOSHANA WAYNE GALLERY, SANTA MONICA.

MARK DION

PLATE VII (R)

ELEPHANT BIRD EGG, DETAIL, **BURIED TREASURE**

FROM THE COLLECTION OF CRANBROOK INSTITUTE OF SCIENCE. PHOTO BY KIRT KING.

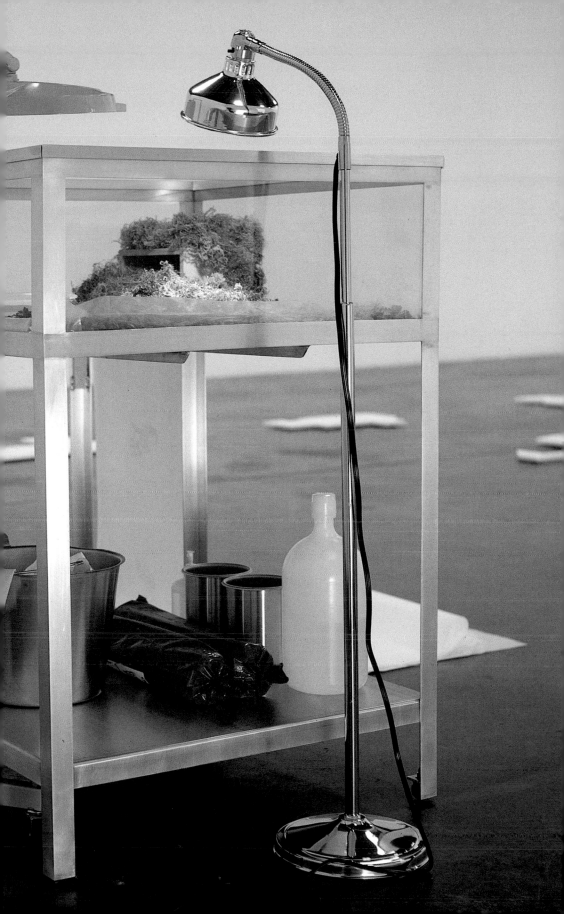

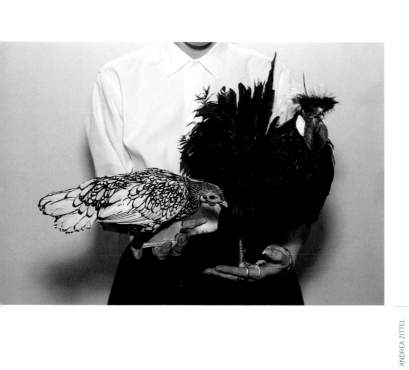

ANDREA ZITTEL

PLATE IX (L) BANTAM BREEDING PROJECT 1991. VIEW OF PARENTS.

PHOTO COURTESY OF ANDREA ROSEN GALLERY, NEW YORK.

MARGARET HONDA

FIG. 14 A (R) DETAIL, 1997- 1997, *TERRAPENE CAROLINA CAROLINA*, VIVARIUM, REFRIGERATOR, GRAPHITE ON VELLUM.

PHOTO COURTESY OF THE ARTIST AND SHOSHONA WAYNE GALLERY, SANTA MONICA.

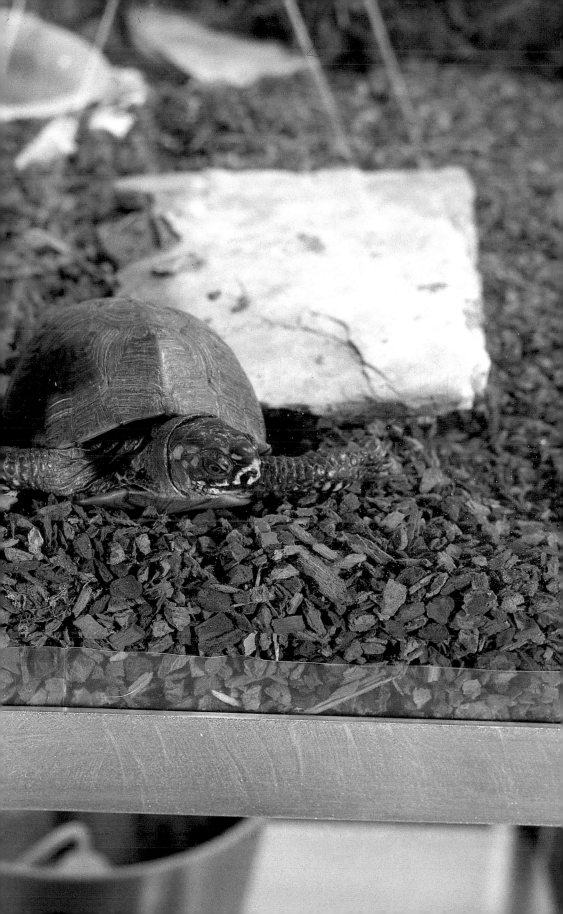

MARGARET HONDA

Margaret Honda's career has been marked by a series of installations and projects aimed at an almost clinical observation of experiences and behaviors of humans, and most recently, animals. Since she was a child, Honda took a great interest in science and research, conducting experiments on her friends in grade school and charting their daily activities. As a teenager, science fair projects also offered her early training in scientific research and problem solving. Honda's tendencies toward research were further developed by graduate work that focused on interdisciplinary studies in early American culture. As much as she enjoyed her early experiences with scientific research, she ultimately felt constrained by science's need for answers. "The prerogative of science is to come up with answers and to have a purpose to each inquiry," Honda explains. It is this very condition of science—its mandate for explanations and conclusions and its search for certain truths—which Honda now challenges in her work as an artist.[15]

Recto Verso, a 1994 installation for the Museum of Contemporary Art in Los Angeles, is an early example of how Honda has translated some of these concerns into her artistic practice. With this installation, Honda explored how vision is constructed and experienced. Honda's research into the science of vision was centered on strabismus, a condition of ocular misalignment that disrupts normal binocular vision (the phenomenon of normal sight that describes the condition of perceiving two separate images combined as one), which she herself was affected by as a child.[16] For *Recto Verso*, Honda combined medical text with a number of sculptural elements to reveal the instability and unreliability of vision—the sense most often connected with experiencing truth. One of the first components of the installation was a quotation from Jules Guerin published in the *Gazette médicale de Paris* (1841). A graphic yet clinical description of an archaic medical procedure—the first operation for strabismus performed on a living subject—this passage served to bring the study of vision to the forefront and provided a context for the seemingly disparate components that made up the rest of the installation. Printed in a light color on an only slightly darker ground, this text appeared at eye level on the walls in a single line around the entire gallery. Challenging to read, the text was only decipherable when visitors stepped right up to the gallery wall. On the floor of the gallery Honda presented a large aluminum form representing the peaks and valleys of a graph.

This particular graph depicted data from a research project on vision and equilibrium for which Honda had been a subject. The graph form appeared to dematerialize depending on the light coming through the gallery and where visitors stood in relation to it. While these elements of *Recto Verso* challenged the sight of viewers, the final component of the installation offered an alternative to vision—another means of understanding the world. Along one wall of the gallery was a library ladder attached to a long track. When visitors climbed this ladder, they discovered a small hole in the wall just within their reach. Inside, visitors could feel a collection of cold, hard, spheres; although they were out of sight, the sense of touch identified these objects as marbles. As a child, Honda was given marbles much like these as part of an exercise to strengthen her weak eye. When asked to find them in a room with only her weak eye, she often relied on her sense of touch instead. The marbles appeared in *Recto Verso* as a means of evoking a sense of discovery and to provide another, more tactile way of understanding one's relationship to the world of objects.

More recently, Honda has moved away from her work exploring human physiological behaviors to examine the activities of nature with a project that focuses on another aspect of looking. *Weird Science* brings together the components that define Honda's most ambitious project to date: a long-term observation of an eastern box turtle *(Terrapene carolina carolina)*. Begun in 1997, this work involves the daily study of the turtle's appearance and behavior, and is a project aimed at gaining a unique understanding of this animal far beyond the usual parameters of science. When Honda initially purchased the turtle she created a custom vivarium and lab set up which allows her to care for the animal and easily view it (FIG. 14 A AND B). Although other observation areas have followed, such as *Terrane 2*, 1998 (FIG. 25), it is this vivarium (built under the guidance of a veterinarian) that serves as Honda's main environment for the turtle. A highly clinical-looking structure, the habitat, titled *1997-*, features a large aluminum table on which a glass enclosure rests. A heat lamp and a broad spectrum light to duplicate sunlight hover above the moss filled environment. A shelf underneath the table houses bottles of water and an assortment of instruments and supplies necessary for maintaining proper levels of humidity and sanitation.

Honda's daily observations of the turtle are articulated in a series of intricate drawings rendered on a long roll of vellum installed on the work surface attached to the vivarium. When Honda has exhibited this work previously in a gallery setting, she and the turtle have been in residence during the run of the exhibition. Although Honda's work with the turtle is not intended as a performance piece—with all of her drawing taking place in the gallery only when it is closed—evidence of her work is revealed during exhibitions by the mass of drawing-filled paper that spills onto the floor near the vivarium. In keeping with the practices of early naturalists like William Beebe (1877-1962), who revolutionized field biology by stressing concentrated research on live subjects for a substantial period of time, Honda's studies are intricate, detailed, and obsessive. While Honda certainly

has many forms of technology, such as photography and video, at her disposal as she carries out her daily studies, she rules out these methods of observation in favor of drawing as a more intimate engagement of her subject. Honda explains, "Drawing allows me a more physical sense of the turtle's structure, how the bend of a leg determines a fold of skin, things like that. I could do that with photography and video, but my relationship to those images would be quite different . . . pencil drawing provides me with a corporeal understanding of the turtle."[17]

Although Honda's daily activities and studies of this turtle are indeed related to, and in fact are largely informed by, the work of zoologists, unlike her scientific counterparts, she does not seek broad conclusions from her work, but rather a deep and meaningful knowledge of the life of one animal. **"MY WORK IS NOT ABOUT DOCUMENTING,"** Honda explains, "it's about constant observation that delves beyond scientific inquiry."[18] Free from the rigid demands of science, Honda's project affords her the luxury of time to observe her turtle's daily life. No matter how uneventful this process may be, Honda's focus is in the looking and the time she devotes to translating her observations into drawings. How much time this project will take is unknown to Honda, since she has committed herself to this work indefinitely until she or the turtle dies.

Since Honda's turtle is in hibernation during the exhibition of *Weird Science* at Cranbrook, she has created a new habitat suitable for the turtle's needs during this period (FIG. 15). With *Hibernarium*, Honda is able to continue her studies of the turtle even though it is in a dormant state (PLATE XII). *Hibernarium* provides a dark, enclosed, temperature-controlled space for the turtle that still allows Honda to view it with the aid of a borescope. Peering into the structure with this instrument, Honda is able to carry out her daily observations and drawings. Although Honda and her turtle will only be in residence at Cranbrook Art Museum for one week during the exhibition of *Weird Science*, evidence of their time spent in the gallery will be documented in the drawings Honda creates. With the construction of the turtle's hibernation habitat complete, Honda now plans to create new and varied environments and observation areas for the turtle, further exploring the life of an individual animal.

MARGARET HONDA | FIG. 15 | HIBERNARIUM | 1993. *TERRAPENE CAROLINA CAROLINA*, ALUMINUM, SINTRA, ORCHID BARK, PAPER, MOSS, WATER, ROCKS, BORESCOPE. PHOTO BY GENE OGAMI. COURTESY OF THE ARTIST AND SHOSHANA WAYNE GALLERY, SANTA MONICA.

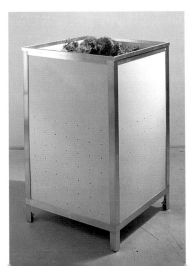

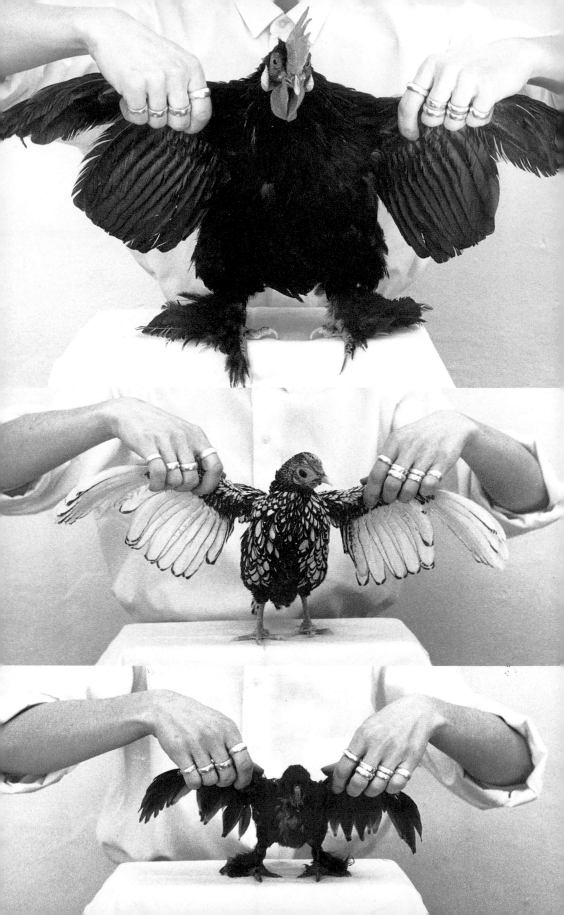

ANDREA ZITTEL

Exploring issues such as order, discipline, social conditioning, and human desire, Andrea Zittel's works have taken the form of various artist-designed products, utilitarian objects and constructions, and social and scientific experiments. From custom-designed food and clothing systems to self-contained multifunctional structures, Zittel has created a body of work aimed at restructuring and bringing order to the lives of individuals.[19] Works such as *A-Z Living Unit* (FIG. 17), or *Dress, Fall/Winter* (FIG. 18), are designed to impose structure onto one's daily life and liberate the user/wearer from clutter and continuous decision-making. Anyone who acquired one of Zittel's *Dress, Fall/Winter*, wardrobes, for example, was asked by the artist to sign a contract promising to store or discard their other clothing and to wear Zittel's garment exclusively for a designated season. Thus, although Zittel's many designs for living focus on efficiency, comfort, and other forms of human desire, at the heart of each of these works is control the conditioning, structuring, and ordering of the lives of others. Zittel explains, "My work is in the organization of a life."[20] Ironically, however, as much as these works seek to introduce fixed structures into daily life, this is often a welcome form of control which relieves individuals from the burdens of necessity. Zittel explains, "It is interesting to find that the imposition of these structures on people makes them feel more relaxed, more in control."[21]

Zittel's participation in *Weird Science* centers around the presentation of her breeding experiments with bantam chickens. Exploring the relationship between creation and human desire, this work challenges notions of scientific progress, bringing attention to the potential dangers of the expanding fields of biotechnology and genetic engineering. Since the early part of her career, Zittel has been interested in exploring the morality surrounding the breeding of animals and the desires that motivate people wanting "improved" new breeds of a given species. "Creation is a form of ownership," Zittel explains, and "breeding is the ultimate form of ownership: the property is life."[22] Through Zittel's breeding activities, she explores

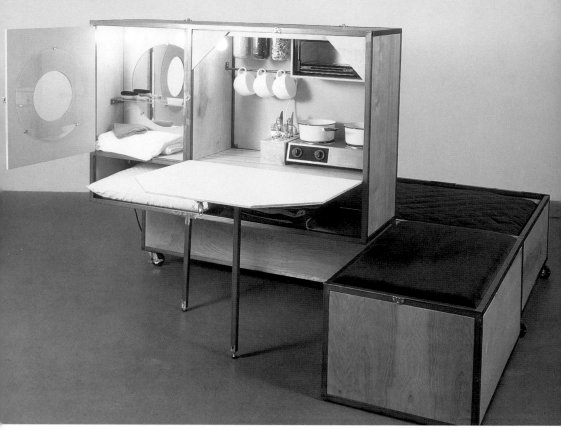

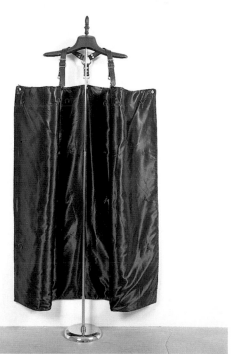

these issues of power and "ownership," revealing the potential dangers of human desires to control and alter nature.

Zittel first began breeding houseflies in 1991, seeking to control their genetic and behavioral evolution through living environments she created for them. Then she moved on to work with domestic birds—first quails, then ultimately the Bantam chicken, a genetically malleable miniature chicken bred for show and decorative purposes. After researching the science of breeding and bird management, Zittel began to raise Bantams with the long-term goal of creating a new breed of chicken. While much of this breeding project took place privately in Zittel's studio over a number of years, two of the breeding structures utilized for the project were exhibited publicly as a means of beginning a dialogue about the project and its implications (FIG. 19).

The public first got a glimpse of Zittel's breeding experiments when she exhibited *Breeding Unit for Reassigning Flight*, 1993, complete with live chickens, in the Broadway window of the New Museum of Contemporary Art in New York during the summer of 1993 (PLATE X). With this work, Zittel sought to comment on our concepts of evolution and the methodology of genetic engineering. The custom chicken coop's design, based on evolutionary theory, was intended to create chickens that could fly by encouraging the reproduction of only those chickens with the strongest wings.[23] The breeding unit was divided into four chambers, each containing vertically stacked nests where Zittel's chickens could lay their eggs. Each chamber represented a different generation of the breed. In the first one lived two Bantam hens and one Bantam cock. Only the hen that was able to reach the highest nest produced young, since the eggs in the top nest were the only ones channeled into the next chamber to be incubated. Across the three remaining chambers of the breeding unit, this arrangement was repeated with the nests positioned progressively higher, so that successive generations of birds would

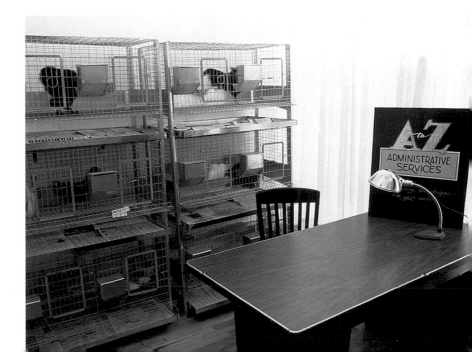

form wings with increasingly greater strength (FIG. 16 A - D).[24] Zittel estimated that it would take approximately two years of such breeding to create a chicken strong enough to fly.

Zittel's next strategy for breeding took the form of a freestanding custom chicken coop called *A to Z Breeding Unit for Averaging Eight Breeds*, 1993 (PLATE XI). This large coop, exhibited in the 1993 Venice Biennale without chickens, was designed to encourage the cross-fertilization of eggs from eight different breeds selected for the project. Theoretically, through a process of interbreeding, recessive traits associated with domestication would be lost and the resulting hybrid bird would retain only dominant traits, creating a more pure and perhaps "wild" form of poultry. Although neither of these more public breeding phases was fully realized, the works brought considerable attention to the complex issues surrounding Zittel's breeding projects. As structures created to encourage specific genetic alterations in Bantams, the breeding units serve as reminders of

HUMANITY'S POWER OVER NATURE

and the unforeseeable implications of breakthroughs and advancements in the name of science. By singling out such idiosyncratic and arguably useless traits in domestic birds, such as flight and "wildness," Zittel's works further demonstrate the subjective power of breeding pursuits and the power of human desire.

Since these two public presentations of her chicken-breeding projects, Zittel has put her breeding work on hold. Not only did she receive countless citations from New York City officials for the possession of "livestock" during this period, but she began to realize that viewers were distracted and even angered by the presence of chickens in her work and were unable to see beyond them to her exploration of the functions of human desire. Aware of the obvious contradiction in her work — the fact that by engaging in breeding, she is ultimately contributing to the very practices she wishes to expose — Zittel is now exploring the possibility of a new direction to her work related to breeding, one that will more clearly focus on the more dubious side of man's desire to alter animals. Zittel is currently searching for the ideal animal on which to focus in this new work — one that will further expose the power and arrogance of human want. The "munchkin," for example, is a new breed of cat that has caught Zittel's attention as a possible subject. This tiny, short-legged feline was recently created by cat breeders out of a desire to have a full-grown cat that maintains its cute kitten-like qualities into adulthood. More disturbing yet is the case of the "fainting goat," a goat that has been bred to appear to faint whenever it is startled. Unnecessary breeding activities such as these reveal the power of humanity to coax desirable, if questionable, qualities out of the animals around us. Zittel hopes to focus on these issues in the next phase of her breeding project.

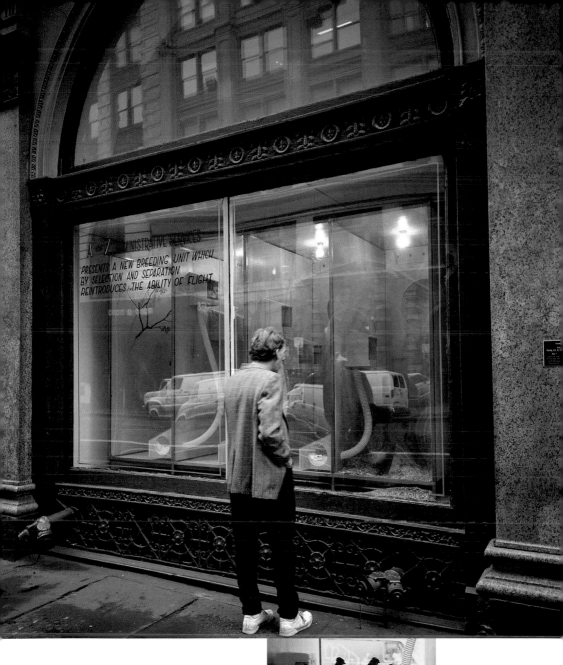

A ** Z* ADMINISTRATIVE SERVICES

PRESENTS A NEW BREEDING UNIT WHICH
BY SELECTION AND SEPARATION
REINTRODUCES THE ABILITY OF FLIGHT

ANDREA ZITTEL

PLATE X

BREEDING UNIT FOR REASSIGNING FLIGHT

THE NEW MUSEUM OF CONTEMPORARY ART, NEW YORK,
FOR EXHIBITION "THE FINAL FRONTIER,"
CURATED BY ALICE YANG, MAY 7- AUGUST 15, 1993.
PHOTO BY PETER MUSCATO, COURTESY OF ANDREA ROSEN GALLERY, NEW YORK.

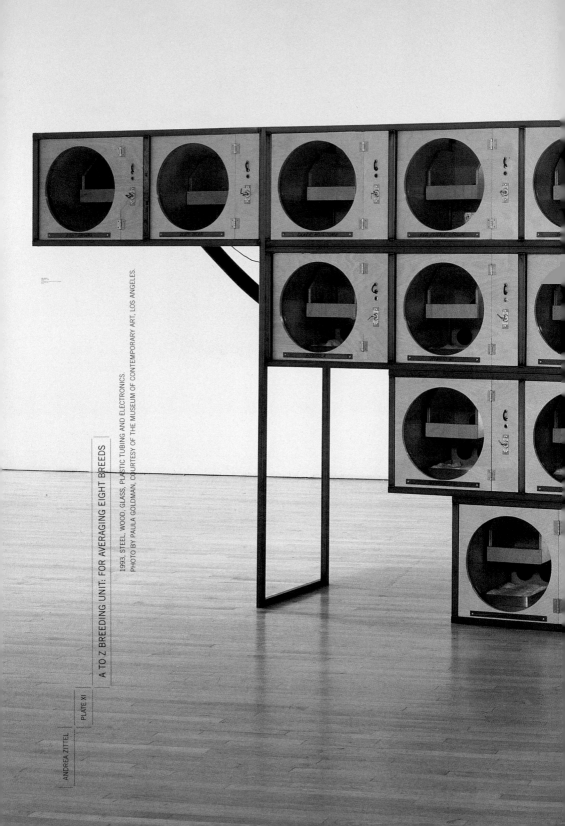

ANDREA ZITTEL | PLATE XI | A TO Z BREEDING UNIT: FOR AVERAGING EIGHT BREEDS

1993. STEEL, WOOD, GLASS, PLASTIC TUBING AND ELECTRONICS.
PHOTO BY PAULA GOLDMAN, COURTESY OF THE MUSEUM OF CONTEMPORARY ART, LOS ANGELES.

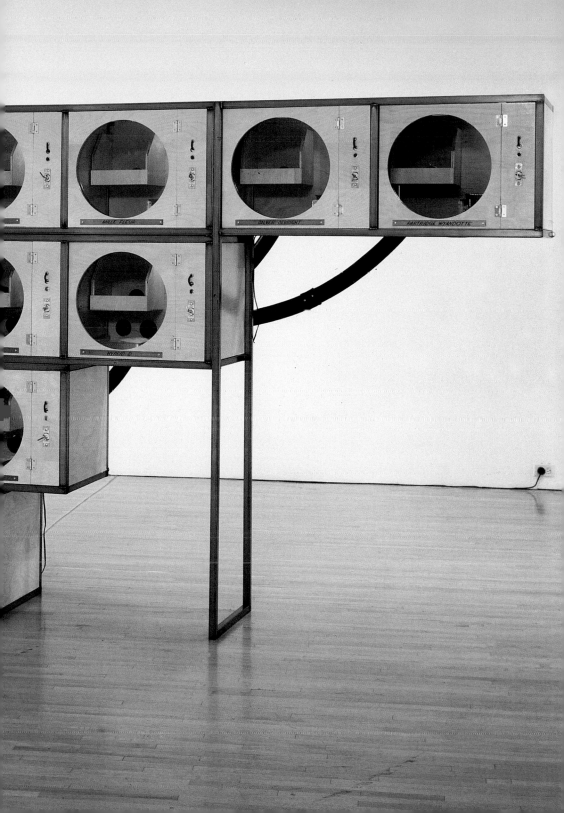

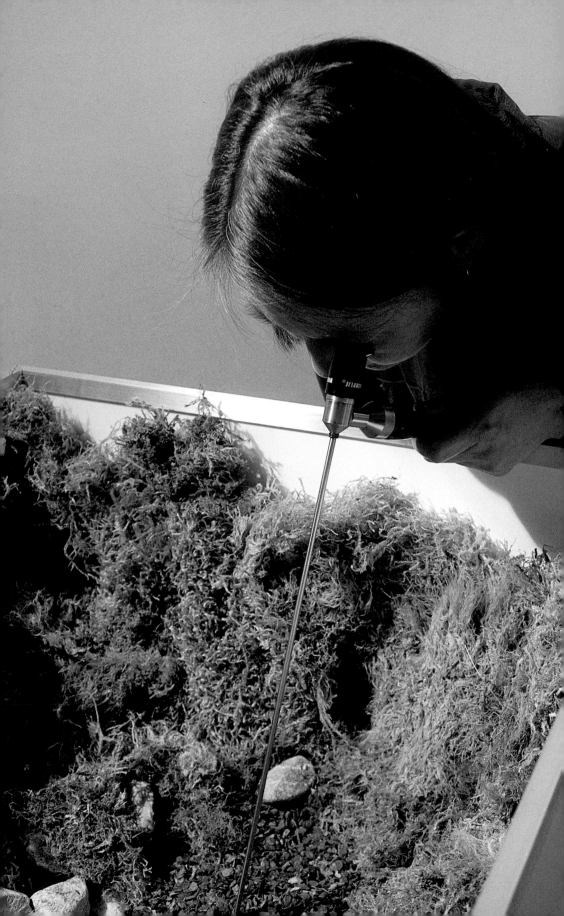

Paleontologist Stephen Jay Gould recently wrote, "The stereotype of a fully rational and objective 'scientific method,' with individual scientists as logical (and interchangeable) as robots, is self-serving mythology.... Scientists should proudly show this human face [of science] to display their kinship with all other modes of creative human thought."[25] Although science may remain wary of such a display, the artists in this exhibition reveal their "kinship" with science through their adoption of its methods and activities and their various dialogues with its practitioners. In spite of the critiques which drive each of the projects in *Weird Science*, each work ultimately reveals the remarkable and sustaining allure of science itself. These works leave us amazed by humanity's advances in scientific understanding and astonished by the extraordinary and mysterious qualities of the natural world.

1 From an interview with Miwon Kwon in *Mark Dion* (London: Phaidon Press Limited, 1997), 11.

2 Lisa Graziose Corrin, "Mark Dion's Project: A Natural History of Wonder and a Wonderful History of Nature," in ibid., 65.

3 Mark Dion, "The Natural History Box: Preservation, Categorization and Display," in ibid., 134.

4 See Sherry Gaché, "Mark Dion," *Sculpture* (February 1998): 69-70.

5 Lorraine Daston and Katherine Park, *Wonders and the Order of Nature 1150-1750* (New York: Zone Books, 1998), 14-15.

6 See Oliver Imey and Arthur MacGregor, eds., *The Origin of Museums: The Cabinet of Curiosities in Sixteenth and Seventeenth Century Europe* (Oxford: Clarendon Press, 1985).

7 Barbara Maria Stafford, *Artful Science* (Cambridge, MA: The MIT Press, 1994), 218, 266.

8 In 1860, the Passenger Pigeon was abundant in New York State. It was even common for the skies to be covered at times with thousands of these birds. Once they became sought after as a source of food their numbers began to drop, until on September 1, 1914, the final member of this species died in the Cincinnati Zoological Park.

9 Dion, "The Natural History Box," 135.

10 From an artist statement by Gregory Green released by Feigen Inc., 1996.

11 Conversation with the author, Bloomfield Hills, MI, August 28, 1998.

12 From *Nuclear Bomb Text*, ink on PVC sheet, 1996.

13 When *Sputnik* was launched, the Soviets purposefully put it into a low level orbit over the Northern Hemisphere so that the satellite could easily be seen by anyone who had a pair of binoculars. Ham radio operators could even pick up the series of beeps it broadcast back to Earth. *Sputnik's* power as an agent of propaganda was undeniable.

14 Text from "Gregnik: An Alternative Space Program," ink on synthetic vellum, 1996, reproduced in *Manual II Gregory Green: A Selection of Works 1986-1996* (Newcastle, England: Locus+, 1996), 58.

15 Telephone conversation with the author, September 26, 1998.

16 Elizabeth A. I. Smith, *Recto Verso* (Los Angeles: The Museum of Contemporary Art, 1994), 6.

17 Telephone conversation with the author, September 26, 1998.

18 Ibid.

19 Although these objectives reference the work of early modernists like the De Stijl group and the Bauhaus artists who sought to apply the values of art to everyday life, Zittel explains that she differs from these artists since they were concerned with organizing society at large, while her work functions on a more individual level. See Lynn Zelenasky, *Sense and Sensibility: Women Artists and Minimalism in the Nineties* (New York: The Museum of Modern Art, 1994), 30.

20 Andrea Zittel quoted in Richard Paniscio, "Ones to Watch," *Interview* (March 1992): 18.

21 Andrea Zittel quoted in Benjamin Weil, "Areas of Investigation," *Purple Prose* (Autumn 1992): 32.

22 Ibid., 31.

23 Much of Zittel's knowledge about breeding chickens came from literature sent to her when she registered herself as a breeder. Telephone conversation with the author, August 12, 1998.

24 Alice Yang, *Andrea Zittel: Broadway Window,* flyer (New York: The New Museum of Contemporary Art, 1993).

25 Stephen Jay Gould, *Dinosaur in a Haystack* (New York: Crown Trade Paperbacks, 1995), 94.

MARGARET HONDA

PLATE XII

DETAIL, **HIBERNARIUM**

1958, *TERRAPENE CAROLINA CAROLINA*, ALUMINUM, SINTRA, ORCHID BARK, PAPER, MOSS, WATER, ROCKS, BORESCOPE. PHOTO BY GENE OGAMI, COURTESY OF THE ARTIST AND SHOSHANA WAYNE GALLERY, SANTA MONICA.

ARTISTS' INTERVIEWS

Michelle Grabner is an artist, critic and writer living in
Chicago. She teaches at the University of Wisconsin, Madison.

by Michelle Grabner

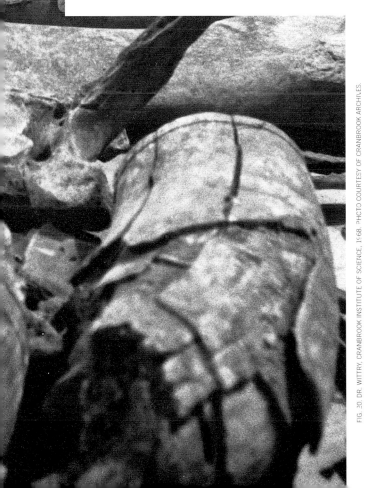

FIG. 20. DR. WITTRY, CRANBROOK INSTITUTE OF SCIENCE. 1968. PHOTO COURTESY OF CRANBROOK ARCHIVES.

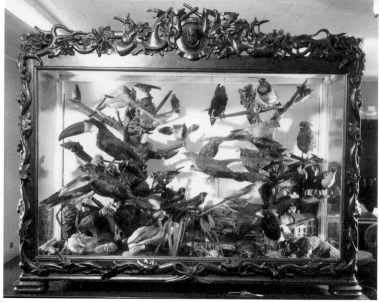

FIG. 21. BIRD CASE EXHIBIT, CRANBROOK INSTITUTE OF SCIENCE, 1961. PHOTO COURTESY OF CRANBROOK ARCHIVES.

MARK DION

Mark Dion was born in New Bedford, Massachusetts in 1961.
He received a B.F.A. from the School of Visual Arts, New York, and
participated in the Whitney Museum of American Art Independent
Study Program. He lives in Beach Lake, Pennsylvania.

MICHELLE GRABNER

Environmentalism has become a soft ideology. With a solid economy and strong international trade, nobody really wants to acknowledge capitalism's detrimental effect on the environment. Do you feel obligated to take on this critique in your work?

> MARK DION
>
> I think you can get into this problem of trying to say everything in every piece and a lot of my early work does that. For instance, I was trying to cram in an entire analysis of tropical deforestation into one work, trying to cover all the bases. It made for an unwieldy project and even an overly didactic one. Now I think more about creating an integrated process that has many different ways of manifesting itself. I think about it more as a war and not a battle. My pieces also have a dialogue with work that has come previously. I'm always trying to correct mistakes, to engage in self-critique which isn't necessarily obvious to viewers who are seeing a work as a discrete object, but if you look at it in terms of my entire practice one can see that self-analysis going on.

So I don't really feel that there is an obligation to critique, but these are issues I am interested in anyway. And even though I am entirely pessimistic and I believe the world is going to the toilet and that there is virtually nothing on the horizon that's going to save the things that I'm interested in—biological diversity, long term sustainablity, less people in the world looking better as opposed to more people looking worse—I'm going to go down fighting.

You have said, "I want to understand this thing called curiosity—a desire for knowledge that is so strong that it leads one to make incredibly irrational decisions." Henry Walter Bates, Alfred Russell Wallace, William Beebe and Charles Waterton, 19th and early 20th century naturalists who inform your research, had unexplored territories to discover. Where does our curiosity for the natural world lead us today?

While I was doing research here at Cranbrook, I met the resident paleontologist and Curator at the Institute of Science whose specialty is fossil whales. Instead of going out and doing digs in the field, he goes to museum basements and storage rooms and looks at long neglected, misclassified, unknown artifacts that are housed in various collections throughout the world. It is a type of internal search. There is also this popular program called Outward Bound, where you take people from the city and put them in the country. I like to think of my work as "inward bound." For instance, in *Concrete Jungle,* a project I worked on with Alexis Rockman, we went looking for animals and biological phenomena in the city and in ourselves. When I did the project *The Department of Marine Animal Identification of the City of New York,* it was no less an expedition than going to the Amazon. It just happened to be an expedition going over a few blocks to Chinatown. We are still, no matter how much we would like to deny it, indebted to biological processes. The only reason we survive is because of the processes of photosynthesis and the long chain of connections that eventually ends with us on top of the food chain.

Do you observe any "irrational decisions," errors in judgment, moral or ethical, in which contemporary research in the natural world is being conducted?

You always have to ask "why." Why would someone want to do research to locate the gene that produces homosexuality? There is this saying in science, "whatever can be done, should be done." Most science today is not disinterested. Science, technology and industry cannot be separated. Genetics is a business, an industry, and like every other kind of industry we can expect abuses, we can expect that there will be unforeseen accidents, we can expect that there will be decisions made about the direction of society without public input. On the other hand, for the public to have any input we must be educated in these things. Most people don't know how many chromosomes we have. The degree of scientific illiteracy is very high and that makes us, the public, less likely to have any intelligent input into the direction of research.

How effectively does the gallery double as a laboratory? Do you sense the same excitement of discovery in natural history museum collections and archives as in the field?

I think that's interesting because at a certain point the science of life was about looking at dead things in a museum. Taxonomy and systematics were how you studied life. The method of how things got there was pretty certain. God created specimens and science's job was to finesse the details, assemble a collection. So people like Kubier and Lemarc thought they were at the end of their project. They enumerated the things that existed, naming them, completing Adam's task and Noah's task. The model of studying life from the basement existed for a very long time until you have people like Beebe looking at life from real things, realizing that the best place to study tropical butterflies is in the tropical forest, not in the basement of the museum. Now we see a rediscovery of the basement with DNA research. I believe very strongly in the value of having a collection. Collections are not just evidence of empirical progress and colonial endeavors but they are a very valuable resource to chart how the world is changing. For example, if we see a high mercury level in tuna we can look at a tuna collected two hundred years ago and see how high the level is. Maybe the tuna naturally accumulated mercury. Maybe mercury made other kinds of physiological changes in the tuna. How fast does evolution work? To know that you have to study the specimens from the past. These collections aren't just booty, they are truly valuable things we can learn a lot about. Of course, the ethics of collecting has changed.

Do you intend for your work to have pedagogical impact?

In some ways, yes, but not in a way that preaches to you. I like to insert contradictions in my work. Sometimes I'm interested in creating a demonstration model of what is wrong as opposed to what is right. Rather than wagging your finger and saying "those colonial nineteenth-century naturalists were bad," I might choose to reenact their project to indict ourselves in the indulging of that fantasy. A fantasy that has constructed our own identity and our own sense of history and nature. It's important to me that my work speaks in a kind of voice that a lay person has some access to. That's not about making my work dumber. I judge a project in its situation and that determines my mode of address.

At what point did the search for scientific knowledge divorce itself from aesthetics?

I don't think it ever did. After visiting dozens of natural history museums, dozens of laboratories and operating theaters, there is a definite aesthetic. Science has a "look" that resides in a very unacknowledged territory. Art and science work together. For example, chemical molecules where given colors in the 1950s and we still recognize those color choices today.

How has new technology altered the aesthetics of the natural world, its tools of research and their implicit romance?

Whether you believe in the biophilia hypothesis that we are genetically programmed to like nature or whether nature is a way we tell stories to one another—we grow up with teddy bears and learn our ABCs from animals—we construct a very elaborate relationship with nature even if we don't experience it first-hand. Nature television is enormously popular and just filled with glorious images and is about making the invisible visible. But it also transfers the same values we have toward entertainment onto nature. Nature is less than perfect. These films set up an expectation that nature can't live up to, but I do think that being out in the field reeducates you and allows you to transcend those expectations. Most people are willing to change their perception in the face of nature rather than being entirely controlled by the filmic image.

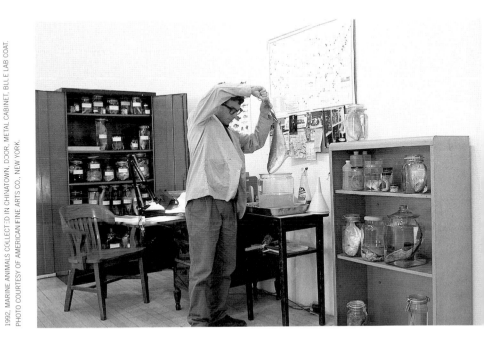

THE DEPARTMENT OF MARINE ANIMAL IDENTIFICATION OF THE CITY OF NEW YORK (CHINATOWN DIVISION;

1992, MARINE ANIMALS COLLECTED IN CHINATOWN, DOOR, METAL CABINET, BLUE LAB COAT. PHOTO COURTESY OF AMERICAN FINE ARTS CO., NEW YORK.

MARK DION

FIG. 22

GREGORY GREEN

Gregory Green was born in Niagra Falls, New York in 1959.
He received his B.F.A. from the Art Academy of Cincinnati, and his
M.F.A. from the School of the Art Institute of Chicago.
He lives in Brooklyn, New York.

MICHELLE GRABNER

Does the banner of art provide you with an excuse to dabble in territories that might otherwise be considered morally and socially unacceptable?

GREGORY GREEN

No. Absolutely not! As a matter of fact, I have been told by a number of people both in the art world and outside of it, that my subject matter is inappropriate material to be discussed or explored by an artist. Of course that is a completely idiotic statement, and when I would press them as to whether it would be appropriate material if I was a photographer or filmmaker, the answer would invariably be "yes." I think that this makes a rather curious statement about the potential power of representational sculpture, as well as commenting on society's relationship to the photographic and film image and a history of desensitization to that form of representation.

Do you feel your investigation into forms of power and physical destruction is actually contributing to its evolution?

Due to the cultural devaluatioĭn of fine arts to nothing more than decorative objects, I would have to say my work has minimal to no effect. The real visual power today lies in Hollywood.

Are you ever concerned that your projects could backfire and cause real damage or injury? How do you safeguard against accidents? Do you impose limitations or draw ethical lines that you just will not cross?

No, I am not concerned about my work causing any real injury of damage. I am sure you are referring to the bomb work which may be mechanically complete and potentially functional. However, it does not contain any actual explosives. If it did, I would have been arrested by the FBI many years ago, regardless of whether or not it was considered art. Secondly, the only objects that are fully functional and used as they were intended are those I morally support the use of, for instance my pirate radio stations.

As you continue your investigation into strategies of empowerment, do you personally experience any of the invincibility and power associated with violent acts? Or are you clinical and objective in your research?

I have personally always been a rather passive and non-violent individual, prone to the use of words or my legs as a form of self-defense. I have never been in a fight and, unlike previous generations, I have been blessed by never being called to fight for my country. So I do not know what that experience might be like and I have not felt invincible since I was a teenager. The closest I have ever come to real violence is when the teenage son of a woman that I lived with in Chicago was shot in the back of the head by gang members, and the concepts of invincibility or power were the farthest things from my mind. I am rarely if ever clinical and objective in my research or production, particularly in the beginning of a new body of work. As a matter of fact, at some times I react with the same sort of horror that some people have felt when viewing my work. Yet the longer I spend with that work, the more numb I become to its horror.

FIG. 23. AD FOR *GREGNIK PROTO II*, 1997. PHOTO COURTESY OF THE PUBLIC ART FUND, NEW YORK.

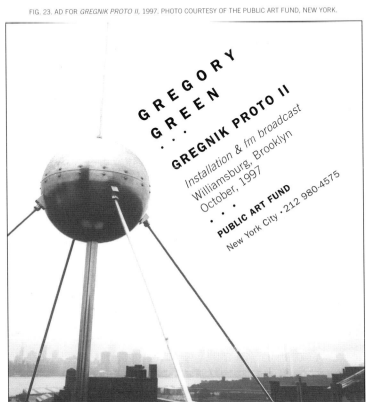

When does function give way to aesthetic form in your work?

Never and always.

I remember your early *Shoot Drawings* dating back to the eighties and being seduced by the exquisite formal qualities you achieved by shooting various types of ammunition at large sheets of paper. Except for these drawings, guns seem to be conspicuously missing from your arsenal. What are your thoughts on guns and their relationship to fear in the everyday as well as the partisan politics they inspire?

I have made one or two homemade guns, but they do not interest me because they are already available to any idiot out there. As to the rest of your question it is very simple: the only guns that should be legal are traditional hunting rifles, all others should be confiscated and outlawed. As to the politics of gun control, all I can say is that if the present direction in the approach to political dialogue continues in Washington, this country and our children are doomed.

Your Terror Group works have often created a great deal of media attention when they have been exhibited both in the U.S. and abroad. How does this media interest effect the work?

The placement of a potentially functional bomb in the traditional sanctuary of the gallery and museum space, or even the assertion that a bomb could be a work of art, creates an environment ripe with tabloid potential. This is intensified by the fact that the objects give no clue as to the maker's moral or ethical position. I am generally forced to respond to a question as to whether or not I am advocating terrorism. This is the perfect segue to my actual goal of a discussion and promotion of an alternative to the utilization of violence and my own belief that the use of violence as a strategy of empowerment is declining and will eventually be abandoned. The media interest, of course, has had a secondary effect as well: it has created a level of interest in my work that has allowed me to pursue larger and more ambitious projects.

Your *Gregnik* project certainly seems to be one of your most ambitious projects to date. What have you learned so far and what's the next step after *Proto III*?

My research on the production and design of the *Gregnik* prototypes as well as the booster rockets has led to an interesting discovery. Not only are most of these technologies much simpler than you would ever guess, they are also much cheaper to produce than one could imagine. I have been more than shocked at the utter simplicity of most things that the average person would consider incredibly complicated. With *Proto III* complete, I am now focusing on the launch of *Gregnik*. I am currently beginning discussion with a contact from N.A.S.A. and other agencies, with the intent to enter a dialogue with the necessary governmental agencies, here or abroad, with a view to assessing the feasibility of scheduling such an undertaking. I am also beginning discussions with two separate individuals in the U.S. and England in a search for

funding for the production and launch of the final satellite. As a conceptual piece, this research in itself will be remarkable, and will form part of the finished work, but when and if the piece is placed in orbit this project has the potential to have global impact.

Is _Gregnik_ a layman's attempt at controlling the most effective form of contemporary power: information?

Yes, as well as an attempt to illustrate to my viewers the potential that any individual may achieve if they just ignore their own self-doubt and not fear failure.

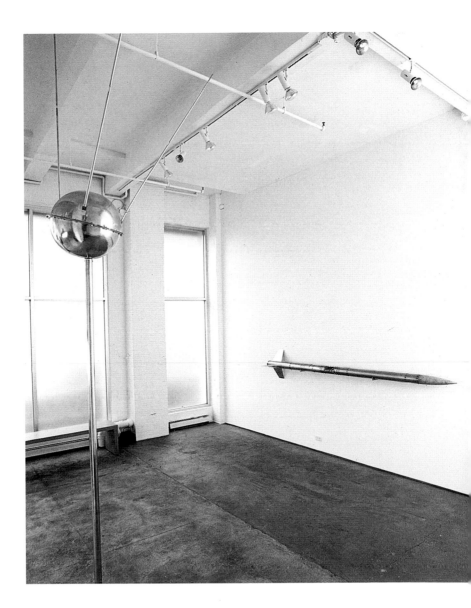

FIG. 24

PROTO I AND FIDO

1998, PHOTO COURTESY OF FEIGEN CONTEMPORARY, NEW YORK.

MARGARET HONDA

*Margaret Honda was born in San Diego, California in 1961.
She received a B.A. from the University of California, San Diego,
and an M.A. in Material Culture from the University of Delaware.
She lives in Santa Monica, California.*

MICHELLE GRABNER

Hibernarium is an interesting hybrid of field observation, scientific experimentation and sculpture. What are your aesthetic concerns and how are they connected to scientific objectivity and issues of truth?

MARGARET HONDA

I've always been partial to the aesthetics of science, not just the material things but the whole system of gathering and interpreting information. In designing *1997-* [Honda's vivarium] and *Hibernarium,* I chose to make them look the way they do because they are tools for collecting and presenting the most straightforward observations. Although it's impossible to remove yourself as a filter, it is possible for the pieces themselves to connect visually with the notions of rationality and objectivity and, hence, with the notion of being able to get to some level of truth about what you are dealing with. Labware, for example, is manufactured from materials like tempered glass, stainless steel, and certain types of ceramics and plastics because of their impermeability and non-reactive nature. It's that level of detachment in the surfaces alone that I find interesting, because it's very much about the idea of objectivity being structured into everything at every level. The issue of truth is a slightly different matter; because my work is sculpture and not science, it can admit to truth by non-scientific means.

Is there an inherent critique of scientific practice in your projects or a strain of environmental politics?

1997- didn't start from a point of critique. My concerns had to do with developing something over a period of time. But there is a very subtle critique that can be inferred, not of scientific practice itself, but of the context in which that practice takes place. Science as we know it is expected to yield results, often marketable results, within a specific period of time.

But practice itself is different from the set of expectations that go along with it. All of the work you do is really in the service of ferreting out information that will disprove a conclusion, or at least raise more questions. The process of gathering data is often the most interesting thing to do simply because you're just looking. It's slow and tedious and not glamorous but it's why you do any of it at all. The Curator of Anthropology and Archeology at the Cranbrook Institute of Science had expressed his wish to be able to devote as much time to field studies as I am devoting to the turtle. There is a desire just to engage in long-term observation to a degree that isn't really available to him anymore. I understand what he is talking about. You get to a certain point and other considerations besides actually doing the work tend to take up a lot of your time.

Is your *Hibernarium* a microcosm of a macrocosm?

In relation to most non-behavioral science of the last century or so—biology, chemistry, biotechnology—it seems out of proportion. On the other hand, there are the large-scale technological advances of the past thirty-five years such as manned space missions and the Mars Pathfinder that make *Hibernarium* seem very small. When we are talking about the scale of this piece, both in terms of relative size and, by extension, relative importance, I think we need to be aware of what exactly is being compared and why. I've just selected the two most prevalent models we encounter when discussing science—that which takes place on a molecular level and that which takes place beyond the Earth's boundaries. These are two ways of practicing science that get a lot of attention because they generate a lot of funding. I find it interesting that these two types of practice involve subject matter that is not visible without the aid of satellite relays or particle traces. Who isn't intrigued by new imagery and new gadgets? Science is nothing if not an act of imagination and a leap of faith to start with, and one of the things it can do is develop the tools that allow us to see and manipulate these other worlds. And this takes place within the whole range of scientific practice, whether it yields spectacular results or mundane pieces of data that are part of a larger inquiry. If we look at *Hibernarium* in terms of the issues of visuality, then scale doesn't really matter.

Do you feel your work sheds an optimistic light on a harmonious union between the natural world and the cultural world?

I don't know if my turtle ever lived in the natural world. He is of that world but he will always live in spaces constructed by me. Its not exactly harmonious because the arrangement is far more artificial for him than it is for me. Perhaps the most important affinity I can point to is the fact that our comprehension of each other is based solely on what we discern by instinct.

I also know that working on this piece—drawing the turtle, developing new spaces for him, maintaining his enclosure—is something that I enjoy. I think the natural world, while it has been subsumed by the cultural world, still has a certain degree of integrity that is impenetrable. I think the optimism in this piece comes not so much from attempting a harmonious union between the two worlds as it does from the fact that I know the turtle will always be a mystery and therefore, he will continue to be a surprise.

How does popular culture frame nature and does it impact your work?

Nature programs on television are completely fascinating to me, probably for all the wrong reasons. Often, there is an attempt to establish some sort of drama by anthropomorphizing. Things also have to happen within, for example, the one-hour time slot, so everything takes place in a compressed period of time. And whatever does happen is afforded an importance it might not have if you were standing in one location and couldn't see what was going on beyond a group of trees. Nature is selected for us and even in my work, I can't pretend to be doing anything different. However, I choose to emphasize the lack of drama, the endless hours of sleep and hanging out that yield a completely different sense of life. There are twenty-four hours in a day, and you're very lucky if, in any five minute period, you can see a non-domesticated animal doing anything as exciting as it might be doing on television or even in a photograph.

New York artist and garden designer Paula Hayes includes a maintenance contract when she creates a "living" work for a client. Do you have the same provisions in mind for your turtle should you chose to sell *Hibernarium*?

I have similar provisions in mind for other pieces, but *Hibernarium* is a somewhat different situation. *Hibernarium* is a tool, like the other objects in the project—the vivarium and *Terrane,* so far, and there are other spaces I'm working on. There is a definite beginning and end to the useful life of these pieces. The project as a whole must continue in my care until one of us dies, even if it were to be sold. If I were to die first, the provisions I have made are for someone to care for the turtle in the same environment for the remainder of his natural life. However, my contributions—drawings, the construction of new spaces—would cease. If the turtle were to die first, all activities would cease and the project would exist only as the objects.

At what point did science and artmaking intersect in your life?

When I was twelve or thirteen, I began entering science fairs, huge city-wide affairs where you would compete against other people from other schools. What I didn't realize at the time was the extent to which I was developing certain interests and certain methods for addressing those interests that just became the way I make things. My science projects were the precursor to my sculptures. I did one on biorhythms where I made people keep meticulous track of their activities over a period of time. There was another one about defining positive and negative spaces. They were all about the process of looking and observing. It's interesting to think about them now. I wish I still had my trophies.

MARGARET HONDA

FIG. 25

TERRANE 2 (OBSERVATION AREA)

1998. POLYETHYLENE. COURTESY OF THE ARTIST AND SHOSHANA WAYNE GALLERY, SANTA MONICA.

ANDREA ZITTEL

Andrea Zittel was born in Escondido, California in 1965.
She received a B.F.A. from San Diego State University, and
an M.F.A. from the Rhode Island School of Design.
She lives in Alta Dena, California.

MICHELLE GRABNER

How does sculpting the perfect chicken relate to your understanding of order and discipline in everyday living? And how did the chicken breeding units lead to your organized living units for humans?

ANDREA ZITTEL

In many ways my work breeding animals, and the structures that I make for my own use, are two distinctly separate bodies of work. But I do think that there is a certain common ground in that they both explore ways in which we construct values and categories which we believe are objective and rational, and yet in reality are totally subjective or inventive.

While I was working on the breeding project, I simultaneously began to make my first *Living Unit* for myself simply because I needed the furniture. I had been moving around a lot during the previous eight years and I wanted a really solid piece of furniture that could serve many different functions, but which also could be collapsed and transported if I needed to move again. I thought that owning this piece of furniture would be a lot like owning a house, but one which could be moved around and installed inside of the houses that other people owned.

Of course in the meantime I had already begun to notice that during studio visits the topic of conversation would usually sway at some point to my *Living Unit,* and I began to realize how this work touched on so many of the issues that we all have to deal with in our day-to-day lives. It also seemed a little amusing to use myself for experiments rather than my animals. Perhaps the most frustrating thing about this switch was when people thought that, instead of making cages for animals, I was making cages for people, which was not true at all. If anything, these pieces were meant to function as a means to invert limitations into luxuries.

FIG. 26. INDUSTRY BROCHURE ABOUT THE PROPER CARE OF CHICKENS USED FOR EGG PRODUCTION. COURTESY OF FARMER AUTOMATIC OF AMERICA, INC.

SPECIFICATIONS:

Width of Cage Row54"

Width of Cage19.09"

Depth of Cage20"

Height to Top of Cage 4th Deck80"

Length of End Units (Total
Automation)96"

Increments of Cage Row Sections . . 19.09"

Area of Cage Floor Space381.8 Sq"
 with 10 birds/cage 38.18 Sq"
 with 9 birds/cage42.42 Sq"

Birds per foot of Cage Row
 at 10 birds/cage50.29
 at 9 birds/cage45.26

Farmer Automatic

OF AMERICA, INC.

Do you view the coops as a model for real scientific research?

I don't really think the type of breeding that I was doing was all that scientific. I was much more interested in using the process of breeding as a means of exploring the function of human desire. The way that I breed animals was very simple and the way that I worked was much more like someone with a backyard hobby. The whole reason that I was interested in Bantams in the first place is because they had been invented by hobbyists and served absolutely no practical function. I wanted to try to figure out what motivated people to continually invent new breeds as well as to maintain old ones.

With a little research, I found that most domestic breeds, even those in dogs and cats, have all been invented within the last one hundred years. People talk about them as if they are natural divisions or races which should be carefully maintained. It seems to me that people create breeds in animals because of their desire for an identifiable, organized, stable social structure.

I'm interested in the position you take as an artist, designer, researcher and engineer. You maintain artistic authority and privilege over your productions even though they potentially target the masses and ultimately strive to create social change. Are you interested in modeling your career after designers like the Eameses or IKEA? Or are you looking to invent you own hybrid marketing that can flourish in the existing structures of the art apparatus?

First of all I think my work actually questions the desire for artistic authority. Even though people often claim to desire individuality and free choice, they still seem to choose the tangible value of an art object authored by an expert over a possession in which they have a creative hand. I produce many of my pieces only as prototypes. When people buy the work, they can purchase the prototype or the rights to make a rendition of it.

On one hand the dissemination of my work functions somewhat like a social experiment. But at the same time, I also continue to make designs for my own use, which function more as a form of personal exploration. On this level I have always maintained that my role is one of an empowered consumer. Sometimes I am really alarmed at how many forms of creativity have been eliminated from our daily lives. People used to make almost everything that they used, from socks to soap, right in their own home. I'm not saying that we should revert to this sort of domestic labor, however, I am concerned that most of our creative needs are now fulfilled by consuming.

I once heard this situation explained using the terms "consumer" and "citizen." As a consumer we are conditioned only to make choices between available options, no matter how limited or uninteresting those options are. A citizen, however, would be able to create solutions beyond the range of available options. I think that we should all practice trying to find solutions beyond the presented choice of brand names or stylistic variations.

Do you feel in opposition to the slacker art that has been prominent in the nineties? I'm thinking about the work of Mike Kelley, Cady Noland, Jack Pierson, Paul McCarthy and others?

No. In fact you just named some of my biggest art heroes.

Do you feel everyone could benefit from some sort of reordering in their physical environment? What role does American capitalism play in everyday inefficiency? I heard that when Americans go on vacation, they spend more time shopping than participating in any other activity? How does your work address our inherent drive to buy?

First of all, I don't think that everyone should reorder their lives but I'm really interested in why we keep doing it anyway. I incriminate myself here as much as anyone else, but it really seems to me that instead of maintaining the structures or systems in our lives, we constantly want to trade them in for something newer, better, or even just simply different.

Of course capitalism is a big factor in craving for constant consumption. You mentioned that people shop while on vacation. I would add that even the idea of taking a vacation itself is a form of consuming, as are many other forms of leisure-time activity. Even the notion of self-improvement has become a mega-industry. It's interesting that you bring this up because I am in the middle of working on a public sculpture for Central Park that touches on some of these issues. I want to address the way in which the nineteenth-century concept of nature as leisure is now, in the twentieth century, reinterpreted as "recreation." At the time when Central Park was first designed, nature, finally having been mastered, was perceived as standing in opposition to the corruption of industrial society. People spent their leisure time in nature relaxing and enjoying tranquil activities such as reading or simply walking along a promenade. Now, recreation attempts to re-inject a sense of danger or excitement back into nature. It reconstructs the adventure or the risk once associated with the wilderness, but as packagable and predictable experiences.

The key to the true success of these new designs really has much more to do with how we perceive their encompassing ideology rather than how they actually look or function. This is what commercials and magazines do all the time. They construct expectations and values around products. I think that it is a good exercise to attempt to create one's own standards, as well as to think about where the preexisting ones actually came from. Once white walls in someone's house meant that they were poor and couldn't afford colored paint—now white walls are a mark of elegance and sophistication. Values exist as the interpretations, they are not inherent in objects themselves.

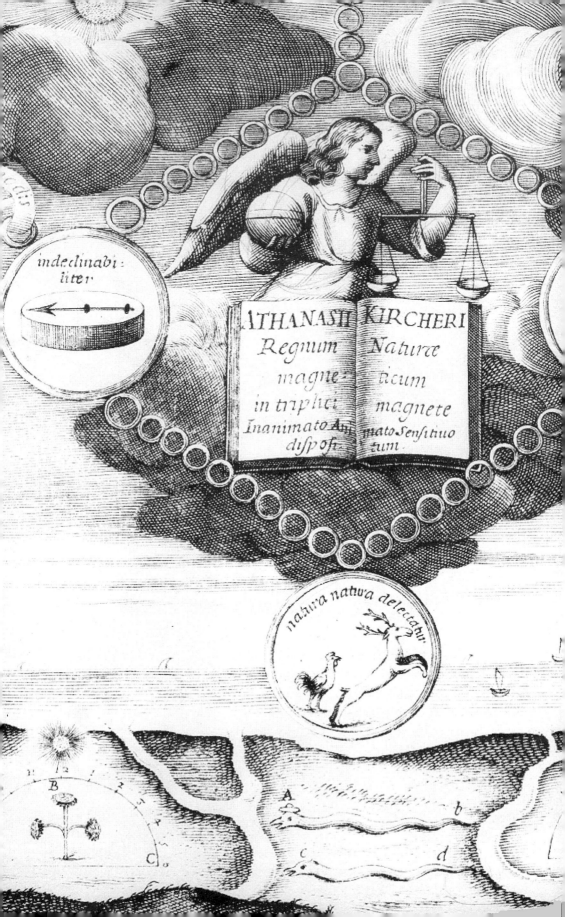

indeclinabi:
liter

ATHANASII KIRCHERI
Regnum Naturæ
magne ticum
in triplici magnete
Inanimato Ani mato Sensitiuo
disposi- tum.

natura natura delectatur

A DESIRE TO EXPLORE THE MYSTERIES, ODDITIES, AND MARVELS OF NATURE, SCIENCE
AND TECHNOLOGY HAS MADE ITS WAY INTO CULTURAL CONSCIOUSNESS RECENTLY
DUE IN PART TO THE ACTIVITIES OF DAVID WILSON, THE FOUNDER, CREATOR AND
DIRECTOR OF THE MUSEUM OF JURASSIC TECHNOLOGY IN CULVER CITY, CALIFORNIA.
A REPOSITORY OF BIZARRE AND EXTRAORDINARY OBJECTS, RELICS, ODDITIES, AND
DRAMATIC EXHIBITS OF SCIENCE AND TECHNOLOGY, THIS UNASSUMING STORE-FRONT
MUSEUM SERVES AS AN EVER-CHANGING TWENTIETH-CENTURY *WUNDERKAMMER,*
PROVOKING ASTONISHMENT IN ALL WHO COME TO VISIT. AS WILSON ONCE EXPLAINED,
HE IS "INTERESTED IN PRESENTING PHENOMENA THE OTHER NATURAL HISTORY
MUSEUMS SEEM UNWILLING TO PRESENT." IN THIS ESSAY, WILSON OFFERS HIS
REFLECTIONS ON THE WORK OF ATHANASIUS KIRCHER, A SEVENTEENTH-CENTURY
ITALIAN SCIENTIST, INVENTOR, AUTHOR AND EARLY PROGENITOR OF "WEIRD SCIENCE."

—*IRENE HOFMANN*

THE WORLD IS BOUND WITH SECRET KNOTS

THE MUSAEUM KIRCHERIANUM

by David Wilson

In 1650 Kircher published the *Musurgia universalis.* His longest work, *Musurgia* became one of the most significant treatises on music theory in its time. *Musurgia* traces the roots of music to natural forms with a section on birdsong, in which Kircher transcribed the song of the nightingale, the cock and hen (both laying and calling her chicks), the cuckoo, quail, and the parrot. In *Musurgia,* as well as his later *Phonurgia nova,* Kircher also dealt with the physical properties of music, specifically acoustics and the propagation of sound. After an exhaustive treatment of music theory from a variety of viewpoints, the *Musurgia* ends with a discussion of the unheard music of the nine angelic choirs and the Holy Trinity.

IN THE CENTER OF MID-SEVENTEENTH-CENTURY ROME, arguably the center of the Western world at the time, stood the Musaeum Kircherianum of the Society of Jesus. This extraordinary institution, perhaps the most famous museum in Italy, replete with Egyptian obelisks, automata, mythical creatures and illusion-producing optical contrivances was, in the words of Sakiya Hanafi, "the exquisite fruite of (the) extraordinary mind" of Athanasius Kircher. And at the center, at the heart, of this remarkable museum, which again, stood in the center of Rome which in turn stood at the center of the Western World — at the center of this museum, surrounded by huge and hugely impressive monuments and mechanical devices, could be found a tiny lodestone — a small, naturally-occurring, strongly magnetic object — the key to the museum and, according to Kircher, the key to the understanding of the workings of creation. "Magnetism," Kircher wrote, is the "path to the treasure of the entire world." To him it was an Ariadne's thread which could lead the curious out of the labyrinth of the seeming incomprehensibility of nature.

Magnetism, or in a broader sense the magnetic virtues, were for Kircher not only a tangible physical reality but (as observed by Paula Findlen in her insightful work, *Scientific Spectacle in Baroque Rome*) magnetism was also a metaphor for all natural operations, and so a metaphor for the workings of the universe. In the Kircherian sense, magnetism is the science of sympathy and antipathy (attraction and repulsion). Thus understood, the magnetic virtues can be seen as the science of sympathy and antipathy encompassing all forms of sympathetic action — so called "action

In *Magneticum naturae regnum,* Kircher describes the snake or cobra stone which was discovered in use among the East Indians and was brought back to Rome by Jesuit missionaries and displayed as one of Kircher's prize artifacts at the museum. The stone, which is found in the head of the hooded cobra, acts as antidote to snakebite. In *Magneticum,* Kircher describes an experiment carried out for a large group at the Roman College in 1663, wherein a huge viper kept at the college was induced to bite a dog. Immediately the snake stone was applied to the wound, "where it stuck fast as if held by a nail. After about an hour the stone fell of its own accord, and the dog was restored to health." According to Joscelyn Godwin, the explanation of the stone's efficacy is that it acts as a kind of magnet which, coming as it does from a poisonous serpent, attracts the venom to itself.

at a distance"—which includes not only the forces we know today as magnetism and gravity, but all forms of attraction and sympathetic response extending to human attraction and repulsion, love and hate, and, ultimately, to divine love itself.

If magnetism lay at the center of Kircher's museum, the subject was still but one of an astonishing number of interests which Kircher nurtured and developed both in his museum as well as his voluminous body of written work. In the words of G. J. Rosenkranz, writing in 1852, Kircher was "a naturalist, physicist, astronomer, mechanic, philosopher, mathematician, archaeologist, historian, geographer, physiologist, physicist, astronomer, mechanic, mathematician, humanist, Orientalist, musicologist, composer and poet." Or put more succinctly by Valentine Worth, "We approach now the vast and terrifying subject of Athanasius Kircher." During his life Kircher published forty major works in Latin and when he died in 1680, eleven manuscripts remained unpublished. His published works include five major books on physics and the translation of hieroglyphics, including his early *Prodromus coptus sive aegyptiacus, Lingua aegyptiaca restituta,* and *Oedipus aegyptiacus;* three important books on physics, including his remarkable treatise on optics, *Ars magna lucis et umbrae;* a complete treatise on various aspects of the Noachian Deluge; *Turris Babel,* the fruit of Kircher's research into the biblical account of the tower of Babel; *Historia eustachio mariana,* a history of Kircher's shrine in Mentorella at the site of the conversion of St. Eustace; *China monumentis illustrata,* an extensive

In the mid-1650's, Kircher devised a unique botanical clock. Known today as the *Leguminous* or *Sunflower Clock,* this instrument employed the heliotropic qualities of the sunflower to follow the solar elliptic over the course of the daylight hours. The center of the flower, pierced with a needle, points to a graduated band which surrounds the bloom. As the sun proceeds across the sky and the flower sympathetically follows its motion, the hour of the day can be read by the needle indicator on the surrounding band. A smaller and more portable clock based on the same principle was also devised by Kircher. Known as the *Heliotropic Seed Clock,* this diminutive version employs not the sunflower itself but one of its seeds. The seed pierced lengthwise with a needle is floated in the center of a small bowl or cup. Markings corresponding to the hours are inscribed on the inner wall of the cup. As the seed in sympathetic motion with its parent, the sunflower, also follows the solar path, this compact contrivance also marks the hour.

compilation of Jesuit missionary reports from 17th-century China; *Mundus subterraneus,* which, resulting from Kircher's descent into an imminently erupting Vesuvius, describes an earthly interior of hidden lakes and enormous underground rivers of fire; a book entitled *Musurgia universalis* which became one of the major compendiums of music theory for nearly two centuries; and finally, three significant books on magnetism and the magnetic virtues, *Magnes, Ars magnesia,* and *Magneticum naturae regnum.*

Still, through the extraordinary volume and diversity of Kircher's work we can trace an abiding, if sometimes insensible thread: an all-consuming desire to find the origins of all phenomena and to discern in the enormous complexity of life the basic motivating forces behind existence. As Paula Findlen has observed concerning the Musaeum Kircherianum, "each object lent credence to Kircher's belief that the world was governed by mysterious if unseen forces whose actions unfolded the pattern of the universe."

Mid-seventeenth-century Italy, despite its appearance of remarkable civility, was a hazardous place for someone holding beliefs that could be deemed heretical. The difference between demonic magic (trafficking with demons and spirits) and natural magic (application of natural laws to the greater glory of God) was a fine distinction that, in the first half of the seventeenth century, was often left to be decided by an inquisitor of the Holy Office. In the year 1600, Giordano Bruno, philosopher of the infinite, was led from the darkness of a subterranean cell where he had spent the greater part of eight years into the blazing daylight of a February afternoon where, facing a great and expectant crowd of Roman citizens, he was tied to a wooden stake and incinerated. In the same year Tommaso Campanella,

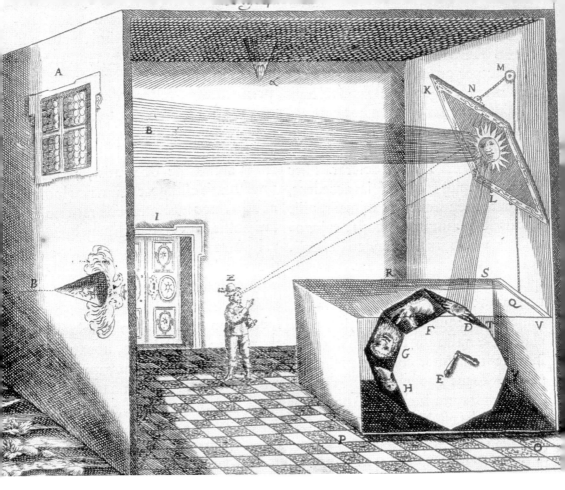

The Musaeum Kircherianum also presented a number of optical devices. Known as catoptric cameras, these devices, consisting primarily of folding mirrors and lenses, were capable of producing apparitions that thwarted even the most astute minds of the day. One such machine featured a wheel painted with the heads of various animals. Using sunlight and a series of mirrors, Kircher contrived an illusion that these heads sat on the shoulders of the spectator.

himself a Dominican, was arrested on charges of heresy and, refusing to recant his beliefs, spent the next twenty-seven years tortured and imprisoned. In 1633 Galileo Galilei was admonished and censured for his heretical endorsement of Copernican beliefs. He was sentenced to life imprisonment until the reconsideration of his cosmological speculations brought his understandings more in line with orthodox views and his sentence was commuted to house arrest. By 1635, the year Athanasius Kircher arrived in Rome, the Holy Office of the Inquisition had come to exert a significant influence in Italian intellectual life. Kircher, at thirty-one years of age, having just received a special Papal commission to study hieroglyphics, could scarcely contemplate heresy. Still, his intellectual appetite was undeniably voracious and a seemingly miraculous combination of political instinct,

Not surprisingly there were also a great many contrivances directly involving magnetics. Among these were devices for magnetic hydromancy and devices for magnetic divination. The frontispiece to Kircher's final opus on magnetic virtues, *Magneticum naturae regnum,* is inscribed with the motto "Inanimato animato sensitiuo dispositum," The World is Bound with Secret Knots.

and a unique if idiosyncratic positioning in the intellectual terrain allowed him to pursue his interests in a by and large undaunted fashion. Kircher's eccentric intellectual leanings certainly would not have been tolerated inside or outside of the Jesuit Order had his unique capabilities (most notably his linguistic abilities and especially his ability to translate the hieroglyphs of ancient Egypt) not been so highly prized by the Vatican. As Barbara Stafford has observed, Kircher enjoyed privileges unavailable to ordinary members of his order; most importantly, he enjoyed extraordinary latitude in his pursuit of highly unorthodox and potentially volatile intellectual interests. In a century at once distinguished by, and distrustful of, the eccentric and exotic, Kircher developed an idiosyncratic body of knowledge and an institution to perpetuate that knowledge that, by his own lights as well as those of the majority of his contemporaries, marked the apex of seventeenth-century Italian intellectual life.

Over the next forty-seven years Kircher published and displayed the fruits of this eclectic research. And since it would be impossible, even in cursory form, to present the full breath of Kircher's research here, I would like to simply present a few areas of interest in an attempt to bring to light the breadth of his work as well as the threads that served to bind this disparate work together.

Kircher deeply understood that magnetism is the key to the understanding of creation, the golden chain, the analogic chain, that links together all of the segments of the universe. Reflecting on Kircher's writings, his Kircherianum and Christendom, the inimitable Valentine Worth states, "All of nature in its awful vastness and incomprehensible complexity is in the end interrelated worlds within worlds within worlds: the seen and the unseen the physical and the immaterial all are connected each exerting influence on the next bound, as it were, by chains of analogy magnetic chains. Every decision, every action, mirrors, ripples, reflects, echoes throughout the whole of creation. The world is indeed bound with secret knots."

COLOPHON

ART DIRECTION	DESIGN	PRINTING	FONTS	FONT DESIGN	PAPER
Laurie Haycock Makela	Brigid Cabry	Cantz, Germany	Didot	Adrian Frutiger	Cover Invercote, 300g/qm
			TRADE GOTHIC	Jackson Burke	Interior BVS glossy, 170 gsm
			WEIRD SCIENCE	Brigid Cabry	

EXHIBITION CHECKLIST

height precedes width precedes depth

MARK DION

Selections from the Herpetology Collection of Cranbrook Institute of Science, 1999
Specimens in alcohol, table,
36x300x36 inches
Courtesy of American Fine Arts Co., New York

Buried Treasure (from the Collection of Cranbrook Institute of Science) I, 1999
Mixed media, 73x64x27 inches
Courtesy of American Fine Arts Co., New York

Buried Treasure (from the Collection of Cranbrook Institute of Science) II, 1999
Mixed media, 73x64x27 inches
Courtesy of American Fine Arts Co., New York

GREGORY GREEN

Gregnik, Proto I, 1996
Mixed Media, 22x11x11 inches
Courtesy of Feigen Contemporary,
New York, New York

Gregnik, Proto II, 1997
Mixed media, Dimensions variable,
Courtesy of Feigen Contemporary,
New York, New York

Gregnik, Proto III, 1998/99
Mixed media, Dimensions variable
Courtesy of Feigen Contemporary,
New York, New York

Gregnik, 1997
Ink on vellum, 24X38 inches
Courtesy of Feigen Contemporary,
New York, New York

MARGARET HONDA

1997-, 1997
Terrapene carolina carolina, vivarium,
refrigerator, graphite on vellum
Dimensions variable
Courtesy of the artist and Shoshona
Wayne Gallery, Santa Monica, California

Hibernarium, 1998
Terrapene carolina carolina,
Sintra, orchid bark, paper, moss,
water, rocks, borescope
Dimensions variable
Courtesy of the artist and Shoshona
Wayne Gallery, Santa Monica, California

ANDREA ZITTEL

A-Z Breeding Unit For Averaging Eight Breeds, 1993
Steel, wood, glass, electronics,
72x171x18 inches
Collection of The Museum
of Contemporary Art,
Los Angeles, California
Gift of Donatella and Jay Chiat

Hisex Brown, 1991
Graphite on vellum,
11 7/8 x 15 1/16 inches
Courtesy of Andrea Rosen Gallery,
New York, New York

Missouri Egg Machine, 1991
Graphite on vellum,
11 7/8 x 15 1/16 inches
Courtesy of Andrea Rosen Gallery,
New York, New York

Lanson Industries, 1991
Graphite on vellum,
11 7/8 x 15 1/16 inches
Courtesy of Andrea Rosen Gallery,
New York, New York

Nicholaus Turkey, 1991
Graphite on vellum,
11 7/8 x 15 1/16 inches
Courtesy of Andrea Rosen Gallery,
New York, New York